ANIMAL CARVINGS
IN
BRITISH CHURCHES

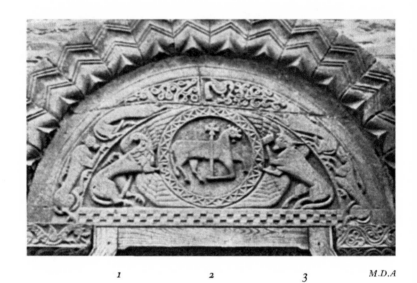

1 2 *3* *M.D.A*

1. ASTON, HEREFORDSHIRE

1. Griffin
2. Agnus Dei
3. Winged Bull

(See pages 4, 27, 69)

ANIMAL CARVINGS
in British Churches

BY

M. D. ANDERSON

(Author of *The Medieval Carver*)

CAMBRIDGE

AT THE UNIVERSITY PRESS

1938

CAMBRIDGE UNIVERSITY PRESS
Cambridge, New York, Melbourne, Madrid, Cape Town, Singapore,
São Paulo, Delhi, Dubai, Tokyo, Mexico City

Cambridge University Press
The Edinburgh Building, Cambridge CB2 8RU, UK

Published in the United States of America by
Cambridge University Press, New York

www.cambridge.org
Information on this title: www.cambridge.org/9780521182058

© Cambridge University Press 1938

First published 1938
First paperback edition 2010

A catalogue record for this publication is available from the British Library

ISBN 978-0-521-18205-8 Paperback

CONTENTS

ACKNOWLEDGEMENTS

My thanks are due in the first place to Mr G. C. Druce, F.S.A., for his kindness in helping me with information and advice, as well as for allowing me to reproduce his photographs. For permission to reproduce photographs my thanks are also due to Mr C. J. Cave, F.S.A., the Rev. A. H. Collins, F.S.A., Mr F. H. Crossley, F.S.A., the Rt Hon. H. A. L. Fisher, Warden of New College, Oxford, and to the Courtauld Institute. For the encouragement without which this book would never have been written, and for much valuable help at every stage of its preparation, I thank my husband, Mr Trenchard Cox.

M. D. A.

23 *Cheyne Walk* 1938

ILLUSTRATIONS

Part I

SOURCES

I

INTRODUCTORY

I have read somewhere that the charm of Chinese poetry lies, not in harmony of sound or even in sensitive lucidity of thought, but in the endless shades of association, some strong, some faint yet haunting, which cling to the ideograms, surrounding the sharply defined meaning of each phrase with an aura of half-seen beauty. It seems to me that something of this shadowy glamour, lying outside the focus of plain meaning, also surrounds the medieval carvings of animals. Many of them are grotesque, few of the rarer beasts bear any resemblance to the creatures they are meant to represent, and yet their appeal is infinitely romantic. The legendary science of the *Bestiaries*, based on strange tales collected from old authors to satisfy the curiosity of a young civilization, and the complicated medieval symbolism which saw the reflection of some act of God in every natural phenomenon, give to the study of these curious beasts a richer quality of interest than scientific accuracy could have afforded. Modern thought tends more and more towards simplification; we try to purge our minds, as well as our rooms, of all that we consider useless, and the absolute truth of what we retain becomes corre-

spondingly important to us. We accept as commonplaces truths about the animal kingdom which the medieval naturalists would probably have refused to believe, while many of the facts which they retail appear to us so fantastic that we can hardly credit their belief. Yet in this clarification of our knowledge something has escaped us which is not without value so long as men's minds are developed by the richness of their imaginative ex-perience. We have not yet charted all the boundaries between the Possible and the Impossible, but each genera-tion helps to draw the line more clearly, and the power of the Known to suggest glowing images of the Unknown is correspondingly diminished. In the Middle Ages so much of the world was unknown to Europeans, and the animals which their limited explorations had re-vealed were so strange, that it is hardly to be wondered at if they allowed their imaginations to roam at will over the seemingly boundless realms of the Possible. If the giraffe could be true why not the basilisk?

The more enlightened students probably believed very few of the Bestiary legends, though they did not con sider that a story made any the worse text for a sermon because it happened to be entirely untrue. Ralph Higden (died 1364) says in his *Polychronicon*: "Though feigning and saws of misbelieved and lawless men, and wonders and marvels of divers countries be yplanted in this book, such serve and are good to be known of Christian men." Whether he was justified in this contention as a general rule does not matter to our present purpose, which is to show that they are "good to be known" of those who

would enjoy medieval carvings to the full and recapture some of that lost aura of association which too much learning has taken from us.

ANALYSIS OF SOURCES

The importance of what we may call these "associative interests" will emerge more clearly when we come to consider the animals in detail. They may be divided into five groups according to their different sources, and these we must now consider:

(1) Animals which typify some particular person.

(2) Animals of the *Bestiary*.

(3) Animals of the Romances.

(4) Heraldic animals.

(5) Animals studied from nature.

For clarity I have also grouped together the various recognizable types of human monstrosities, though they are derived, in many cases, from the same sources as the animals.

The real, or imaginary, habits of an animal will often determine the source of a carver's inspiration, but where these are not illustrated we get no help in determining the importance of the different sources from the comparative frequency with which different animals appear, for the same creatures are generally singled out as especially important in all classes. Thus the lion and the eagle are the symbols of St Mark and St John respectively, have the most complicated histories given them by the *Physiologus*, and are favourite heraldic devices.

(1) *Animals of personal symbolism*. The most important example of the first group is the Agnus Dei, or Lamb of God, which is still recognized as the symbol of Christ throughout the Christian world, while the meaning of most of the animal symbolism of the early Christian art has been forgotten by all but specialists. Isidore of Seville tells how various animals symbolize different aspects of Christ: thus the lamb represents His innocence; the sheep, His patience; the ram, His leadership; the kid, His likeness to sinful flesh; the calf, His sacrifice for us; the lion, His kingship and courage; the serpent, His death and wisdom; the worm that comes from the ashes of the phoenix, His Resurrection; and the eagle, His Ascension.

Next in importance are the four symbols of the Evangelists. From the early days of Christianity men were agreed that the creatures with the faces of a man, a lion, a bull, and an eagle, seen by Ezekiel near the river Chebar, and the four beasts, described in the Book of Revelation, represented the four Evangelists. The symbolism of their identification was explained to the congregations on certain days, by a passage from the work of Rabanus Maurus on Ezekiel, which is preserved in some twelfth-century French lectionaries. St Matthew represented the man because he begins his Gospel with an account of Christ's earthly descent; St Mark begins with the description of the "voice crying in the wilderness" (like a lion), and St Luke's account of the sacrifice of Zacharias in his opening chapter made the sacrificial bull an appropriate symbol for him. St John, who carries

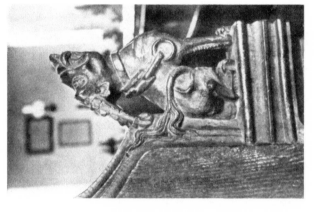

M.D.A. pages 16, 27, 28

2. WALPOLE ST PETER

Natural Antelope

M.D.A. pages 16, 27, 28

3. WIGGENHALL ST GERMAN

Heraldic Antelope

his readers at once into the presence of God, was asso-
ciated with the eagle which, alone among animals, could
gaze undazzled on the sun.

I shall deal with the animals associated with less
important saints as they occur in the catalogue, as also
with the ever popular Dragon, the symbol of the Evil One.

(2) *The Bestiary.* By far the most interesting influence
upon the animal carvings of the Middle Ages was that
of the *Bestiary*, a work whose history we must now
briefly consider. As early as the fifth century we hear
of a book called the *Physiologus* or "natural historian".
The author remains anonymous, but is thought to have
been a Greek monk, living in Alexandria, who was
perhaps influenced by the *Fables* of Aesop, and who drew
his material from references to clean and unclean beasts
in the Bible, and from the works of SS. Ambrose, Basil
and Eustathius on the "Hexameron" or six days of
Creation. He also used Gregory's *Moralia* and the
Etymology of Isidore of Seville, who in turn had bor-
rowed largely from earlier writers such as Pliny and
Solinus, hardly adding any first-hand observations, or
correcting any of their predecessors' errors. Aristotle
had been a distinguished pioneer in the study of natural
history, and his *History of Animals* contained much
correct and valuable information, but social convulsions
caused his works to be ignored in Europe until the
thirteenth century, when they were translated from
Arabic to Latin and played an important part in stimu-
lating the revival of learning. The references to his works
in the *Bestiary* are generally misreadings quoted in sup-

port of fantastic statements, but even if its authors had
had easy access to his writings it is probable that they
would have preferred the more colourful authorities who
misled them. Pliny's *Natural History* was the richest
mine of information for the medieval student who wished
to enlarge his knowledge beyond the limits of his own
observation, but although there was much valuable in-
formation in Pliny he also had depended largely on the
writings of others, such as Ctesias and Megasthenes,
which were more full of wonders than facts. The
Physiologus had a wide distribution, being translated
into many languages; there are Syriac, Armenian and
Ethiopic texts and even Icelandic. The greater number
of manuscripts remaining are in Latin and French.

In the early sixth century the book was declared to
be heretical, but this does not seem to have lessened
its popularity. Some twelfth-century writer, thought to
have been English, rearranged the entries, which had
hitherto been without any fixed order, classifying the
animals as beasts, birds or fishes. At the same time a great
deal of new material was added, drawn largely from
the works of Isidore of Seville, St Ambrose and Rabanus
Maurus, and the number of chapters rose from the
original 40 to 100 or 150. These later additions are less
fantastic than the original chapters, and their pictures
are generally mere representations of the animals, no
attempt being made to show their characteristic and
symbolical activities. It is therefore almost impossible
to decide whether carvings of these animals are copied
from the manuscripts or from nature.

The chapters generally begin with some Biblical mention of the animal, followed by what the *Physiologus* said about it; the spiritual significance is then explained in an address to "a man of God", and the section usually, though not invariably, ends with the words "well therefore did the *Physiologus* speak concerning" the animal in question.

Later writers also took a hand in reshaping the *Bestiary*; a well-known twelfth-century version was attributed to Hugo de Sancto Victore; Philippe de Thaun* also composed a French version soon after 1121, and Guillaume le Clerc wrote a rhymed *Bestiary* in Norman-French, about 1210, which has been translated into English by Mr G. C. Druce. Perhaps even more important than these paraphrases were the borrowings of the encyclopaedists, who based much of their natural history upon the *Physiologus*; for since their works dealt with every branch of human knowledge, they were naturally regarded as mines of information whence all students might draw material for their own work, and their statements, whether fact or fiction, were thus widely disseminated.

Vincent de Beauvais (*c.* 1190–*c.* 1264) was one of the most important of these encyclopaedists, and his *Speculum Majus* summarizes almost all the human knowledge of the thirteenth century. Since he covers so vast a field (his quotations are taken from about 450 authors), it is no wonder that, in his own words, he "took small

* Translated by Thomas Wright in his *Popular Treatises on Science in the Middle Ages*, 1841.

pains to reduce the sayings of the philosophers to con-
cord, striving rather to repeat what each hath said
on every matter ". The more modest encyclopaedia of
Bartholomaeus Anglicus, an English Franciscan who
taught at the University of Paris, in 1230, is of impor-
tance to us for two reasons: it was written for the use
of Franciscan friars at a time when these were preaching
in many English villages, and its similes therefore were
made familiar to the common people, and it was one of
the most widely read books of the Middle Ages, retaining
its popularity until the sixteenth century.

At first sight it seems curious that in an illiterate age
the influence of the *Bestiary* should be so great as to
outweigh that of direct observation, but this is certainly
the case. Not only do the carvers infinitely prefer to
represent animals which they are most unlikely to have
seen (and some of their renderings make it painfully
obvious that they had not seen them), but even in dealing
with creatures with whose real habits they must have
been familiar, they do not hesitate to follow the *Bestiary*
in its most fantastic mis-statements. If the *Physiologus*
says that stags eat serpents by all means let them be
shown doing so, however unlike the ways of the native
red deer it may seem (fig. 17). When it was supposed
that most medieval churches were designed, down to the
last detail, by ecclesiastics, this seemed natural enough,
but the pendulum of praise has swung the other way
now, and the bishops and priors are only allowed the
credit of having financed buildings designed by master-
masons. That the carvers did not fully understand the

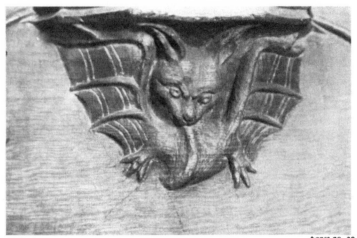

M.D.A.

pages 29, 30

4. EDLESBOROUGH

Bat

F. H. Crossley

pages 14, 28

5. MANCHESTER CATHEDRAL

Apes robbing a Pedlar

symbolism of the subjects they represented is made clear by the endless variations on every theme which are to be found in their work. Each legend affected the creative genius of the age like a pebble dropped in a pond, the sharply defined inner circle corresponding to the correct carving, directly based upon a manuscript illumination, the last ripples, distorted by reeds and stones, to the senseless "baberies" which dimly reflect the original design. It is beyond the scope of this book to deal with the close connexion which exists between the more correct carvings and the manuscripts, but readers will find a wealth of information on this point in the articles of Mr G. C. Druce. How far the majority of carvers had access to illuminated copies of the *Bestiary* is impossible to determine; the library of any cathedral or large monastery would have possessed a copy whose illustrations might well have been used as the basis for decorative designs, and it is on the stalls of such churches that we find the most correct illustrations of *Bestiary* stories after the twelfth century, when the secular mason's lodge had supplanted the monastery as the training school for carvers. The countless inaccurate versions of beasts and legends to be found in parish churches throughout the country probably reflect the attempts of illiterate carvers to reproduce the designs seen in the mason's lodge attached to some cathedral, where they had been temporarily employed.

In English carvings the *Bestiary* subjects generally appear alone, their symbolism unexplained by the surrounding subjects. In France the symbolism of the animal

kingdom was much more closely connected with the system of teaching by type and antitype, whereby events in the Old Testament were made to prefigure those in the New; the eagle carrying the eaglets up to the sun, or the caladrius are shown in connexion with the Ascension, the virgin and the unicorn with the Annunciation. In the glass at Canterbury and on the south door at Malmesbury we have two fine English examples of this typological decoration, but the coupled subjects are drawn from Old and New Testaments alone, though some animal subjects were probably represented on the outer order at Malmesbury, now sadly defaced.

(3) *Animal Romances.* The idea of endowing animals with the characteristics of human beings and causing them to enact imaginary dramas which satirize the faults of men has been popular with writers of all ages and nations, from Aesop to Uncle Remus and from La Fontaine to Walt Disney, and as yet it shows no sign of losing its power to please. Although it was not until the Middle Ages that the romance of *Reynard the Fox* reached the height of its popularity its origin can be traced back to the seventh century. A "rustica fabula" of the Lion, the Fox and the Stag, following the style of Aesop, is quoted in Fredegar's Chronicle, *c.* 612, and in the ninth and tenth centuries Latin poems were written relating events in the Beast Epic. About 1148 a Flemish priest, Nivardus of Ghent, wrote a Latin poem, called first *Reinardus Vulpes* and later *Ysengrimius*, in which the beasts for the first time bear the names which later became so closely associated with them that the original

French word for a fox, *goupil*, has been entirely super-
seded. Although the question of whether this romance
is of French or German origin has been endlessly debated,
there can be no doubt that it was in France that it
enjoyed its widest circulation. About 1250 a Flemish
poem called *Reinaert de Vos* was written by one Willem,
and although his poem contained 3474 lines, Willem
left the story incomplete and a further 4000 lines were
added by an unknown Flemish author in 1370. From
this poem most of the later versions are derived, including
that translated into English and printed by Caxton at
Westminster in 1481. Although the full continental
version was not adopted in England until later, variants
of the fable were evidently known in the thirteenth
century, for Odo of Cheriton (died 1247) uses the Reynard
stories in his sermons, and Chaucer's *Nonne Preestes Tale*
is in the same tradition, though the "col fox full of
sleigh iniquitee" is called Dan Rossel.

A lengthy synopsis of the romance would be out of
place here, as, though it frequently inspired the carvers,
they limited their choice of subjects to very few incidents.
The fullest series of such carvings occurs on the miseri-
cords in Bristol Cathedral. Three of these show the mis-
fortunes of King Lion's messengers betrayed into the
fox's traps by their own greed; Bruin is caught in the
hollow tree where he expects to find honey, and Tybert
the cat finds a trap instead of mice in the priest's barn.
Three more misericords illustrate the trial and execution
of the fox; the latter scene was especially popular with
the carvers all over the country.

The story of Reynard was essentially a popular romance; it parodied the tales of chivalry and afforded an admirable medium for satirizing the abuses of contemporary society. In fact the carvers played a part not unlike that of the political cartoonists of to-day. Many additional episodes, recounted by travelling tale-tellers, were grafted on to the original romances in order to give such satires a wider application, and the *Roman du Renard* printed by Méon in Paris in 1826, which includes a good many of these off-shoots, runs to 40,000 lines. The countless carvings of foxes in monk's clothing, and of apes doctoring, probably derive from these tales, the most important of which, from the carver's point of view, is the *Shifts of Reynardine*. This tale relates how Reynard's son is encouraged by his friends the apes to impersonate a doctor, and equipped by them with the necessary implements, stolen from a sleeping pedlar's pack; a scene shown on misericords at Bristol and Manchester (fig. 5). Later Reynardine tries to become a monk, and when he is expelled from the monastery for stealing he makes a living as an itinerant preacher, reading aloud, or preaching, until geese draw near, when he proceeds to dine off a member of his congregation. The subject of a fox preaching to a flock of poultry was even more popular with the carvers than his execution; on a misericord at Ely the fox holds a scroll in his paw, presumably representing the text which was shown in a window in St Martin's, Leicester: "Testis est mihi Deus quam cupiam vos visceribus meis" (God is my witness how much I long for you in my bowels).

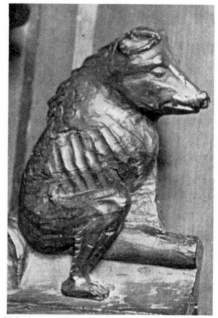

 page 31

6. STOWLANGTOFT

Wild Boar

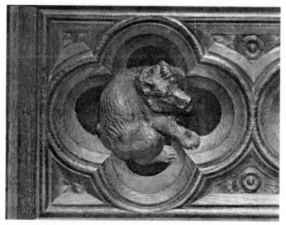

 page 30

7. LINCOLN CATHEDRAL

Bear

(4) *Heraldic animals.* The early history of heraldry is so uncertain that it is almost impossible to decide how far it originated the devices which are now associated with armorial science, or adopted them, with their symbolism already determined, from other sources. The need of a distinguishing sign for a person, or for a community of persons acting in unison, was so obvious, and its use at all times so universal, that it cannot be claimed as heraldry unless we are prepared to include the totem poles of Red Indian tribes in the same category as the armorial blazonry of Europe. Many of the animals which we now regard as mainly heraldic can trace their descent to a period of history when heraldry, as we now know it, did not exist, and the creatures were adopted as personal badges because of the symbolism which legend, or theology, had already attached to them. The fact that heraldic animals were used as badges at early periods does not prove the coexistence of heraldry.

The same difficulty confronts us when we wish to decide whether the carvers took the heraldic animals, which they frequently represent, from shields and badges, or from the original sources whence the heralds also derived them. Sometimes, as in the case of the antelope, the heraldic form differs sufficiently from the natural to be distinguished from it, and the heraldic antelope (fig. 3), being well known as a royal badge, has been represented by carvers all over the country and is more often shown than the natural antelope (fig. 2). On the other hand the heraldic double-headed eagle is comparatively rare, though the natural eagle can be seen

in almost any church where there is much decorative carving. This fact is, however, inconclusive, since both forms of eagle were used in heraldry. The decorative form of the pard is said to have been derived from the lions of the royal arms of England, called "leopards" by the French heralds, who only recognized the existence of the lion rampant, but none of these facts is of sufficient weight to justify us in attributing to the heralds of the Middle Ages much credit for having originated the animal forms they used, though it is highly probable that they did a great deal to popularize them. In an age when the art of reading was confined to a small proportion of the population, the value of distinguishing devices, as apart from real heraldry, was far greater even than that of their closest modern equivalent, the trademark. It was not only the nobles who used their badges to distinguish their retainers and their belongings, the wealthy merchants had personal marks with which they stamped their wool-sacks and decorated the churches which they built, as for instance at Lavenham and Long Melford in Suffolk, or Cullompton and Tiverton in Devon. Thus the whole population was accustomed to translate symbols, whether animal or abstract, not only into theological ideas but also into personalities. The merchants' marks very rarely included animal forms, the wool-sack appealed to them rather than the sheep, but animals have always enjoyed a prominent position in heraldry and it was probably through this medium that many of the carvers obtained their ideas as to the forms of unusual creatures. Since animals used in heraldry were always

conventionalized, and since conventionalization is always welcome to the designers of decorative sculpture, we find in heraldry another force driving the carvers farther and farther away from nature into the domain of far-fetched fantasy.

It is probable that badges played a much greater part in thus inspiring the sculptors than either crests or coats of arms, for, whereas both the latter were personal, worn only by the owner and on comparatively rare occasions, the badge was merely a mark of ownership, and, as such, was widely displayed. Thus a great man's badge would be familiar to a large number of the common people who would never have seen either his crest or his coat of arms. The rebus or punning, pictorial signature was also a popular device, chiefly used on buildings to commemorate the founder, and specially popular with highly placed ecclesiastics. These rebuses often included animal forms, as for instance the cock of Bishop Alcock at Ely, Jesus College, Cambridge, and Little Malvern, the owls of Bishop Oldham at Exeter, the couchant stag of Abbot Lyhart at Norwich.

(5) *Animals studied from nature.* When we have enumerated all the animals which the medieval carvers derived from various literary sources and from heraldry, the most striking fact about the remainder is their rarity. Scenes of daily life include many figures of domestic animals, but they are rarely the centre of interest. Dogs are fairly plentiful on bench-ends, but they are not as a rule carefully carved; differences of breed are ignored and the varieties of the genus dog in medieval churches

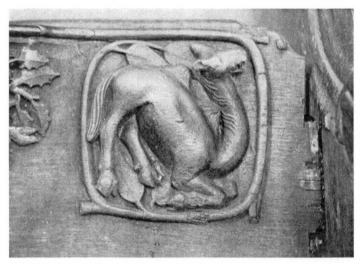

G. C. Druce

8. BOSTON

page 31

Camel

Courtauld Institute

9. STONE, BUCKS.

pages 34, 60, 71

Crocodiles and Pygmy

can only find their counterpart in French provincial towns! Horses, in spite of our national interest in them, are very rare, cattle almost equally so, while ducks and hens are much less common than unicorns.

The insect world is poorly represented; a butterfly occurs on one of the stalls at Lincoln; snails appear on a capital at Wolborough, Devon, in the north chantry of Lincoln Cathedral, and on the stalls in St George's Chapel, Windsor, but insect forms did not appeal to the carvers, and, with the exception of the bee and the ant, even the authors of the *Bestiary* did not use them to illustrate their tales.

III

HUMAN MONSTROSITIES

By men whose minds were accustomed to implicit belief in the wildest perversions of natural history, the supposed existence of races of equally monstrous men was easily accepted as probable. A passage from Sir John Mandeville's *Travels* (1357–71) will give an idea of the variety of human distortion which medieval minds could conceive.

In these isles there are many manners of folk of diverse conditions. In one of them is a manner of folk of great stature, as they were giants, horrible and foul to the sight; and they have but one eye and that is in the middle of the forehead; they eat raw flesh and raw fish. In another isle are foul men of figure without heads, and they have eyes, in either shoulder one, and their mouths are round, shapen like a horse-shoe, in midst their shoulders.In another isle are folk whose ears are so long that they hang down to their knees.In

another isle are men that have their overlip so great
that when they sleep in the sun they cover all the visage
with that lip. There is an isle where the folk
have but one foot and that foot is so broad that it will
cover all the body and owmbre it from the sun. Upon
this foot will they run, so fast it is a wonder to see.
Many other manner of folk there are in other isles
thereabouts which were too long to tell all.

Sir John is now dismissed as a traveller whose real
voyages were probably confined to his own land, his
imaginary ones based on the reports of others, but even
real travellers were almost as credulous, their books as
full of wonders. The tradition of these terrible beings
had been handed down through many centuries before
Sir John Mandeville made use of it in his travels. Ctesias,
doctor to Artaxerxes, *c.* 400 B.C., never visited India,
but his writings preserve the legends current at the
Persian court as to the strange beings who dwelt there.
About a hundred years later Megasthenes was sent on
an embassy to Benares, and in his account of his travels,
reminiscences of Ctesias mingle strangely with recorded
facts; already tradition was strong enough to challenge
the contrary evidence of the traveller's own senses. Isidore
of Seville in his *Etymology* and Rabanus Maurus in his
De Universo collected many of these stories, at the same
time bestowing upon them the sanction of their authority.
In a ninth-century manuscript from Beauvais, now in
the Bibliothèque Nationale in Paris, there is a document
purporting to be a letter from one Fermes to the Emperor
Hadrian in which more of these marvels are described,
in the form of a report on the progress of an expedition

sent to capture strange men and animals. This letter of Fermes was both shortened and supplemented from other sources to form the *Wonders of the East*, a manuscript which spread the knowledge of these strange beings in the eleventh and twelfth centuries. Individually the human monstrosities had not, as a rule, any religious symbolism, though the giant symbolized Saul, the pygmy David, but taken as a whole they were considered as so many witnesses to the wonderful scope of God's law by which all creatures however strange and debased have souls to be saved.

IV

GROTESQUES

All the recognizable animals I have observed in English churches can be fitted into one or other of the above categories; there remains only the strange fauna of medieval fantasy, grotesques which defy classification, hybrids no legend can justify, nightmare hordes with neither name nor kind. When it was supposed that all medieval sculpture was necessarily symbolical, the gargoyles on the outsides of churches were explained as demons fleeing from the power of the Church, or baffled by it in their attempts to enter and attack the congregations; the famous "Lincoln Imp" is supposed to have entered the cathedral with evil intent and there been miraculously petrified. This theory has now been abandoned and the conception of these grotesque beings more reasonably attributed to the exuberance of creative fancy among the carvers. But even though we give up the attempt to

explain gargoyles I think it would surprise the casual
visitor to know how many of the apparently meaningless
grotesques could have been used as illustrations of the text
in Job xii. 7: "Ask now the beasts, and they shall teach
thee; and the fowls of the air, and they shall tell thee."
Origen expressed the basis of much medieval teaching in
the following words: "The visible world contains images
of heavenly things in order that by means of these lower
objects we may mount up to that which is above."

Medieval theology was so complicated that parables
were a necessity if congregations of simple folk were to
grasp its meaning. The pictorial parables that are shown
in the carvings had another advantage which has been
somewhat overlooked, while stress has been laid on their
use as an alternative to written instructions, in days when
few could read. To illustrate this other advantage we
must recur to the parallel I drew in my opening paragraph
to the ideograms of a Chinese poem, for, as the number
of associations suggested to the mind of a reader would
increase or diminish with the extent of his culture, so
the ideas suggested to the mind of a medieval observer
would have varied in proportion as he was educated to
receive them. The decoration of a medieval church was
not merely a picture book for the benefit of the unlettered,
by the help of which a preacher could make clear his
meaning, but it afforded visual stimulus to the minds of
all beholders.

So ends our brief survey of a strange world, governed
in its early stages by laws of symbolism as all-embracing
as the nineteenth-century theory of mechanistic explana-

10. WHALLEY *page 36*

Fox and Birds

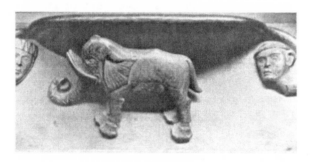

11. EXETER CATHEDRAL *page 35*

Elephant

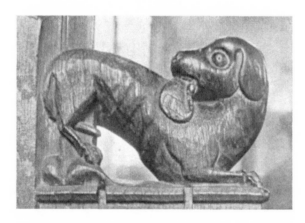

12. LAKENHEATH *page 34*

Dog

tion and as fantastic in its escape from reality as the work of any modern surrealist. In the catalogue of creatures that follows I am well aware that some of my readers will probably disagree with my identifications. In trying to classify designs in which the forms of mis-representations are infinitely varied, it is impossible, or at any rate highly imprudent, to be didactic; and as Vincent de Beauvais held that belief or disbelief in his contradictions would not imperil his readers' faith, so I hope that agreement or disagreement with my classi-fication will not lessen my readers' interest in the subject.

Part II

LEGENDS

BEASTS

Agnus Dei. A catalogue of symbolical animals could not begin more appropriately than with the "Lamb of God", the most widely recognized of such symbols. The fact that its form is derived from the Book of the Revelation as well as from the words of St John the Baptist probably accounts for its great popularity with the carvers of the twelfth century, who were generally more interested in Apocalyptic subjects than those of the succeeding ages. It is always shown holding a cross in its forefoot (frontispiece).

Antelope. The antelope was said to be a fierce, untamable beast, armed with serrated horns with which it could cut down great trees. It fell a victim to the hunter because, after drinking at a stream, it took delight in thrusting its horns into the bushes on the bank until they became hopelessly entangled (Manchester Cathedral —misericord). It thus symbolized the man who, armed with knowledge of the Old and New Testaments, had power to destroy evil, and yet delivered himself to the Devil by his indulgence in immoral pursuits. The beauty of the natural antelope is in great contrast to the ugliness of its heraldic form which was very popular with the carvers, probably because it was widely known as a

royal badge. This creature has the body and head of
a heraldic tiger with the legs of a deer, a tusk projecting
from the tip of its nose, and two short, serrated horns.
The carvers are inclined to bestow on it the further
horrors of boar's tushes (figs. 2, 3).

Ape. The ape typified fraud and indecorum. It was
largely used by the carvers to illustrate satires upon
contemporary abuses; thus any ape shown holding up
a urine flask is a jibe at doctors, and the baboon bribing
an ecclesiastic on a misericord in St Mary's, Beverley,
is typical of many satires carved within church walls.
A Darwinian version of the Fall is perhaps shown on
the tympanum of Stanley St Leonard, Glos. More serious
symbolism was attached to the female ape's habit of
carrying her favourite child in front of her when pur-
sued (Tiverton, Devon—buttress), the less loved one left
at her back being exposed to the hunter's arrows. Thus
the Devil will look after his own. This legend may
account for carvings of apes tenderly nursing swaddled
babies. The carvings of apes robbing sleeping pedlars
are derived from the *Shifts of Reynardine* (see p. 14)
(fig. 5). Guillaume le Clerc says there are more than
three kinds of ape but does not particularize them. The
Callitrix, an ape with a long mane and bushy beard,
said to live only in Ethiopia, is represented at Ufford,
and a baboon at Tostock, both in Suffolk.

Bat. Bats were supposed to cling together like swarm-
ing bees, and if one bat let go the rest were scattered,
thus illustrating the importance of union among men.

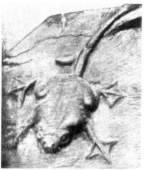

 page 36

13. EDLESBOROUGH

Frog

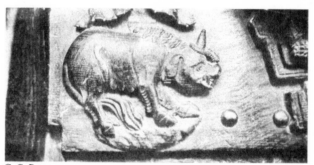

 page 39

14. WINDSOR

Hippopotamus

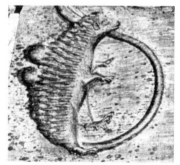

 pages 38, 39

15. OXFORD, NEW COLLEGE

Hedgehog

This fiction, which was probably derived from the fact that young bats cling to their mothers, even in flight, is not shown in carving, but single bats are fairly plentiful. The carvers evidently never studied a dead bat for, though the way in which the membrane of the wing is attached to the sides of the tail is sometimes correctly shown, the "fingers" of its bony structure are always replaced by meaningless lines radiating from the arm like a bird's feathers. At Edlesborough, Buckinghamshire (fig. 4), where a long-eared bat is shown, this mistake occurs, and the "keel" on the breastbone, which is characteristic of the bat's frame, is much more strongly marked than in nature.

Bear. The modern phrase "licking a young cub into shape" is a survival of the *Bestiary* legend which told that the bear's cubs were born as shapeless lumps and then moulded into form by their mother's tongue. This process is not shown in English carvings. Adult bears, however, are frequently, and fairly accurately, represented (fig. 7), for the popularity of bear-fights (Beverley Minster—four misericords) and of itinerant dancing bears (Barfreston, Kent—south door) made these animals familiar objects in the countryside, and these sports are often illustrated. Heraldically the bear and ragged staff of the Earls of Warwick is one of the most famous badges in history (Lechlade, Glos.—tower; Coventry—stalls).

Beaver. The *Bestiaries* tell that the beaver is called Castor because it castrates itself in order to satisfy the hunter who pursues it for the sake of its genitals, which

are of value in medicine. If hunted a second time it turns itself round in order to show the hunter that his search will be fruitless.

Boar. The wild boar is fairly often met with upon the tympana of Norman doors (Ipswich, St Nicholas'). It was the chosen beast of St Anthony of Egypt, for a boar is supposed to have been his companion in the desert for twenty years, and is generally shown beside him in statuary or painting. It symbolizes the "cruel princes of this world" and the Emperors Vespasian and Titus are mentioned as examples in the *Bestiary*. The sullen ferocity of the brute's expression is wonderfully rendered on a bench at Stowlangtoft, Suffolk (fig. 6), though the carver has carelessly given it human feet. Boar-hunts are often illustrated (Beverley, St Mary's—misericord).

Camel. This animal which, when shown kneeling to take up its load, typified Christ, who took upon Him the sins of the world, is fairly common, especially in the eastern counties, but is never correctly shown. The hump is the only feature of its appearance to which the carvers attached any importance. One bench-end at Stowlangtoft shows a good attempt at the bearded head of the Bactrian camel, but the animal's hump has slipped back over its tail. Some examples have one hump, others two. In certain cases the hump is the sole indication that the animal is meant for a camel (fig. 8).

Cat. The cat is almost always shown holding a mouse (Winchester Cathedral—misericord). The vengeance of the mice is illustrated on a misericord in Malvern Priory,

where a posse of them hang a most ill-favoured cat. Occasional "baberies" show the cat playing the fiddle as in the nursery rhyme (Northleach, Glos.—porch). The cat Tybert was a minor character in *Reynard the Fox* and two misericords in Bristol Cathedral illustrate his misfortunes in the priest's barn.

Cattle. The carvers' preference for representing imaginary creatures rather than familiar domestic animals is demonstrated by the comparative rarity of cattle. Apart from the winged bull, symbol of St Luke (Brent Knoll, Som.—bench-end), they only appear as subsidiary subjects. The ox being slaughtered (Worcester Cathedral—misericord) is a frequent illustration of an autumn month in the calendars, and milking scenes occur occasionally. Single animals or groups of cattle sometimes appear on bosses (Exeter Cathedral), but this is rare.

Crocodile. The name was supposed to be derived from its crocus-like colour, and its amphibian habits led to its association with men who lived a double life, and so with the Arch-Deceiver. The crocodile was probably the original of Job's Leviathan and of the gaping jaws which often represent the Gates of Hell. The form of the crocodile was evidently unfamiliar to the medieval illuminators; a *Bestiary* in the collection of Mr Pierpont Morgan shows the crocodile with a serrated mane extending all along its spine. The French *Bestiaries* tell that if a crocodile catches a man it eats him whole, and then weeps for him for ever after: hence the phrase "crocodile tears". The carvings are as unrealistic as the

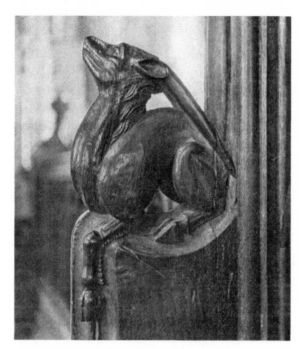

G. C. Druce page 41

16. KING'S LYNN, ST NICHOLAS'

Ibex

Starr & Rignall pages 9, 38

17. ELY CATHEDRAL

Hart eating a Snake

illuminations; and it is very difficult to distinguish the crocodile from other monsters which devour human beings except when it is shown swallowing the *Hydrus* (q.v.). The curious carving on the Norman font at Stone, Buckinghamshire (fig. 9), possibly illustrates both forms of the crocodile legend, for on the left we see a long-legged beast in the act of swallowing some other animal, and on the right, a dragon, not unlike the real crocodile, with a human head and hands beneath its paws.

Deer. See under *Hart.*

Dog. The *Bestiaries* generally illustrate the faithfulness of the dog by telling the story of the King of the Garamantines' return from exile with an army of 200 dogs who overthrew the hosts of his enemies, a subject too complex for the carvers. They also say, that dogs make their wounds heal by licking them (fig. 12). There is a beautiful carving of a starving dog gnawing a bone on a misericord at Christchurch, Hampshire.

Eale or *Yale.* A kind of deer with long horns, one of which points forward, the other backward. Pliny says that their horns are mobile, so that when one is blunted or broken with fighting they can be twisted round and the other used. The only carved eales I know occur in heraldic devices, the finest examples being those on the gateway of Christ's College, Cambridge, the supporters of Lady Margaret Beaufort's arms.

Elephant. The elephant was said to breed only once in a life of 300 years, when the female plucked the mandrake and gave it to the hitherto passionless male.

It thus typified Adam and Eve losing their innocence by eating the forbidden fruit. It was also said to have no joints in its legs and to sleep leaning against a tree, and so was captured by the hunter sawing the tree partly through so that it gave way and the elephant fell helpless to the ground. It trumpeted loudly and a large elephant (the Law) and then twelve other elephants (the Prophets) would come to its aid, but were powerless to help until a young elephant (Christ) came to put his trunk under the fallen one. The dragon was the mortal enemy of the elephant, whose cool blood it longed to drink, and so it lay in the path seeking to ensnare the elephant's feet in its coils; the elephant fell, but in falling crushed its adversary (Dunkeswell, Devon—font). The smell of an elephant's bones, if burned, would drive away venomous serpents. The carvers were uncertain as to the elephant's form, its trunk being their chief stand-by, its legs their worst snare. The attractive carving on the misericord at Exeter (fig. 11) was perhaps based on the elephant presented to Henry III in 1255. The *Bestiaries* often depict the elephant with a castle full of armed men on its back, and tell that Indians and Persians fight in this manner; the carvers usually follow their example (Ripon Cathedral—stalls). The form of old chess rooks (their name derives from the Persian word for an elephant) may have helped to popularize this version.

Fox. The fox which pretended to be dead, so that it might capture the birds which came to devour its supposed corpse, symbolized the Devil laying a snare for

souls, and is sometimes represented in carvings (fig. 10). Many subjects in which foxes appear are taken from the romance of *Reynard the Fox* (see p. 12) with its many variants and additions; the execution of Reynard (Brent Knoll, Som.—bench-end) and the preaching of his son Reynardine to a congregation of poultry (Gresford, Denbigh—misericord) being the favourite subjects. Fox-hunts (Gloucester Cathedral—misericord) are fairly common; though ranked as vermin the fox was considered worth hunting because of his wiliness, but most frequently of all the fox is shown carrying off his prey (Ely Cathedral—misericord), a sight which was probably as familiar to the carvers as it was unwelcome. I have tried in vain to find out whether the fox does in fact carry fowls slung over his back as the carvings almost unanimously declare.

Frog. Frogs symbolized heretics who "wallowing in vilest sensuality do not cease to snarl with vain croakings" (MS. Harl. 4751). On a boss in the Norwich cloisters a frog is seen issuing from a dragon's mouth, as a heresy might be supposed to proceed from that of the Devil. Powdered toad was a favourite ingredient in the necro-mantic medicines of the Middle Ages, and on a misericord in St George's Chapel, Windsor, we see a man having a whole frog, or toad, forced down his throat by three men. The frog at Edlesborough (fig. 13) illustrates the habitual inaccuracy of the carvers, since all four feet are webbed.

Goat. The *Bestiaries* tell us that the Latin word *caper* is derived from *carpendo*, gathering, and that

Phillips, Wells *page* 42

18. WELLS CATHEDRAL

Lizard

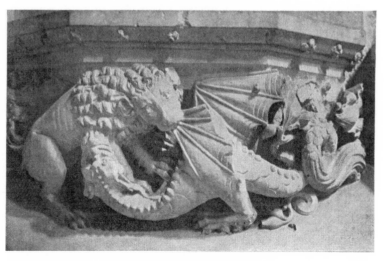

F. H. Crossley 19. BEVERLEY MINSTER *page* 41

Lion fighting a Dragon

goats were so called because of their habit of browsing on the tops of bushes or from *captet* because they climb the heights. It must not be confused with *caprea*, the roe-deer, which also climbs for food. Goats are not common in carvings but almost all the examples I know show them among trees or foliage (Winchester College Chapel—misericord).

Hart. According to the *Physiologus* the hart spent its time in the pursuit of dragons and serpents; its "panting for cooling streams" being due, partly to the thirst engendered by breathing the dragon's fiery breath, partly to its practice of driving serpents from their holes by spewing water down them. Pliny says that because of this enmity between the two animals, burnt hartshorn is the best specific for driving away serpents. The hart is attacking the dragon on the pulpit at Forrabury, Cornwall, and at Ely (fig. 17) it munches a serpent, a diet supposed to help the growth of new antlers. Stag-hunts (Boston, Lincs.—misericord) are common in carving and are usually of purely secular interest, but sometimes they illustrate the legends of St Hubert or St Eustace, both of whom were converted by the miraculous appearance of the Crucifix between the antlers of the stag which they were pursuing. St Giles is another saint associated with deer, and is generally shown protecting the hind which took refuge in his lap (Adderbury, Oxon.—exterior cornice).

Hedgehog. The hedgehog's supposed habit of climbing up a vine, biting off the grapes and then rolling upon them so that it might carry them back to its young

impaled upon its spines, is illustrated at New College, Oxford (fig. 15), and was strangely enough interpreted by the *Physiologus* as symbolizing the wiles of the Devil. The truth of the story is more than doubtful, though hedgehogs have been seen with fruit stuck on their spines.

Hippopotamus. The Westminster *Bestiary* illustrates the hippopotamus (river-horse) as having the head of a horse, with boar's tushes and a dragon's twisted tail. Compared with such a monster, which is probably based upon Pliny's description, the hippopotamus at Windsor (fig. 14) is remarkably accurate. Some pardonable confusion with the rhinoceros accounts for the horn.

Horse. The loyalty of horses to their masters is extolled by Bartholomaeus Anglicus, who says that "many horses weep when their lords be dead", but when they appear in sculpture the interest in them is generally only incidental to the main theme of jousting, hunting, etc. Small, wild ponies sometimes figure on poppyheads (Swavesey, Cambs.), but the carvers were strangely insensitive to the sculptural qualities of the horse's head.

Hyena. The *Bestiaries* generally represent the hyena in an architectural setting, dragging a corpse from its grave. The carver of a boss at Queen Camel, Somersetshire, has followed this precedent, and at Alne, Yorkshire, we have a title to guide us (fig. 20), but elsewhere the fact that it is shown devouring a corpse, or part of a corpse, is the only means of identifying the hyena, and as the

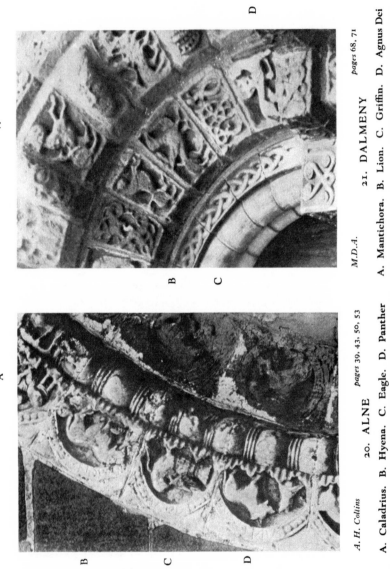

A. H. Collins

20. ALNE pages 39, 43, 50, 53

A. Caladrius. B. Hyena. C. Eagle. D. Panther

M.D.A.

21. DALMENY pages 68, 71

A. Mantichora. B. Lion. C. Griffin. D. Agnus Dei

crocodile also devours men the task of distinguishing
between them in carving is extremely difficult. The
hyena's victim *should* be naked and emaciated as on
a misericord at Carlisle. The hyena was supposed to
be male and female in alternate years and so symbolized
the Jews, who were weak, or a man who was effeminate.

Ibex. The horns of the ibex were said to be so strong
that they would break its fall from almost any height.
The illuminators depict it diving headlong with its fore-
feet tucked back, prepared to land upon its horns. These
horns denoted the Old and New Testaments by which
theologians maintained their arguments. It is rare in
carving and never occurs in this characteristic attitude
(fig. 16).

Lion. The lion had several symbolical characteristics.
(i) When pursued, it obliterated the traces of its footsteps
by sweeping the ground with its tail, thus symbolizing
Christ veiling His Godhead in the Virgin's womb. This
is not shown in sculpture. (ii) It slept with its eyes
open, representing vigilance. This characteristic made it
an appropriate guardian for church doors. (iii) Its cubs
were born dead, but the mother watched over them for
three days, after which time the male lion brought his
offspring to life by breathing upon them. This subject,
which typified the Resurrection, is shown upon a boss
in Canterbury cloister. When the lion is shown fighting
the dragon, as on the Percy tomb at Beverley (fig. 19), it
represents the power of good combating evil. The symbol-
ism is reversed when the breaking of the lion's jaw by

Samson is shown, for the lion represents Hell, the Gates of which were broken by Christ. On the great south door at Malmesbury, this subject is opposed to the Entombment. The *Bestiaries* say that when a lion is sick it eats a dead ape (Windsor—misericord). Other characteristics, not shown in sculpture, are that it fears a white *cock* (q.v.) and spares captives returning home. As the symbol of St Mark the winged lion is often represented on fonts, especially in East Anglia (Aylsham, Norfolk).

Lizard. The lizard was supposed to renew its youth by peering through a crack in the wall at the rising sun. Its likeness to the dragon makes it rather difficult to identify, but it forms the subject of one of the most famous animal-carvings in England, the "lizard of Wells" (fig. 18).

Otter. The fatal lure of etymology led the medieval artists into great confusion as to the appearance of the otter, in spite of the fact that some of them at least must surely have seen one. The Greek word for an otter, ἔνυδρις, means also a water snake, and the otter was therefore endowed with the shape and crocodile-hunting habits of the *Hydrus* (q.v.) (? Windsor—stalls).

Panther. The panther was erroneously regarded as a gentle beast which represented Christ, for after hiding in its den for three days (as Christ was hidden for three days in the tomb) it roared and gave out such a sweet breath that all animals were drawn towards it, with the

exception of the dragon, which retired to its hole (Newton, Yorks.—stone slab). In carving, the other animals are omitted and the dragon is shown retreating into its hole while the panther roars in front of it (fig. 20).

Pard. The pard, which was supposed to be born of the union of a panther and a lioness, is described by the Latin *Bestiaries* as "a spotted animal, very swift and bloodthirsty" and likened to the wicked man spotted with sins. The animal is generally shown in profile, the head turned full-face, with jaws gaping and tongue extended to indicate its bloodthirsty nature. The long, branching tail should be extended, but exigencies of space generally cause it to be returned over the animal's back (Canterbury Cathedral crypt—capital). The spots are rarely shown in sculpture, but they occur at Dunblane, Perthshire. Mr Druce considers that the heraldic leopard was probably derived from the *Bestiary* pard, which it greatly resembles. The pard, being a hybrid and therefore sterile, was considered particularly suitable as a badge for abbots and abbesses.

Pig. The writers of the *Bestiaries* took little interest in pigs, but this did not have its usual effect of making the carvers equally neglectful. The symbolical parallel drawn between the pig which is dirty and does not chew the cud, and sinners who do not meditate upon spiritual matters, is not stressed in carvings, but the familiar sight of a pig eating the acorns which the swineherd shakes down for him occurs constantly

S. Smith *page* 46

22. LINCOLN CATHEDRAL

Squirrel

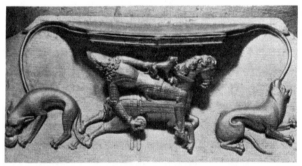

F. H. Crossley **23. CHESTER CATHEDRAL** *page* 48

Tigress deceived

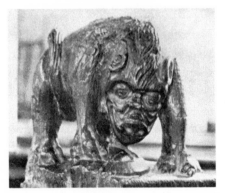

M.D.A. **24. WENDENS AMBO** *page* 48

Tigress and Mirror

(Worcester Cathedral—misericord). The design of the sow and litter is commonly found on bosses as it is easily adapted to a circular form (Ugborough, Devon). It is particularly popular in the west of England, perhaps because of some association with the legend of St Branock, who was told in a vision that he must build his church at Braunton on the spot where he should find a sow feeding her litter under an oak-tree. The terms "sow" and "pig", applied to iron, are derived from the shape of the castings, one large bar with five smaller ones depending from it. Pigs playing musical instruments are frequently shown, the harp and bagpipes being chiefly favoured (Ribbesford, Worcs.—pulpit).

Rabbit. The rabbit lacked symbolical meaning and was too familiar to be interesting; it is therefore rare in carving, but is fairly accurately rendered when it does occur (Wells Cathedral—misericord).

Serpent. Although the Scriptures abound in references to the serpent as the symbol of Evil, the carvers preferred the more dramatic horrors of the dragon's form (fig. 19). When it occurs alone it is generally curled or knotted, as is the common practice of heraldry. The *Bestiaries* tell that when a serpent wishes to drink, it must first vomit away all the venom in its fangs, as a man must purge himself of sin before going to mass, and that when it wishes to change its skin, it scrapes off the old one by wriggling through a chink in a wall. The curious font at Ashford-in-the-water, Derbyshire, which shows a snake, with knotted tail, wriggling

through the bowl, may symbolize the similar sloughing off of sins by baptism.

Sheep. The Latin word for a wether, *vervex*, was variously derived by the authors of the *Bestiaries* from *vires*, strength, *vir*, male, and *vermis*, worm. This last theory was held to explain the pugnacity of wethers by supposing that they had worms in their heads which set up a state of irritation only to be relieved by butting each other violently (Barfreston, Kent—south door). The finest carving of an individual ram is the rebus of Thomas Ramynge on his chantry in St Albans Cathedral. Considering the immense importance of the English wool-trade during the Middle Ages it is very remarkable how rarely the carvers represent any scene connected with it (Winchester Cathedral—corbel showing sheep-shearing). See also under *Agnus Dei*.

Squirrel. The squirrel's supposed habit of crossing water seated on a flat piece of wood is sometimes likened to a Christian's need of holding fast the Cross, while traversing the troubled seas of life. Failing a piece of wood the squirrel would use a leaf as a ferry boat, paddle with its paws and spread its tail for a sail. The large leaf on which the Lincoln squirrel (fig. 22) is seated is probably an allusion to this legend. Generally the squirrel is shown cracking a nut, but at Sall, Norfolk, a careless carver has given it a bunch of grapes.

Tiger. The hunter who captured the tiger's cubs and was pursued by the tigress adopted various ruses to escape her. According to Pliny he threw down one cub

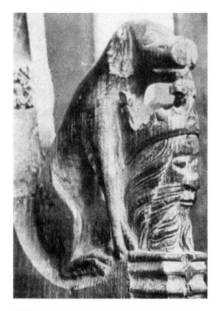

25. WALPOLE ST PETER
Wolf of St Edmund

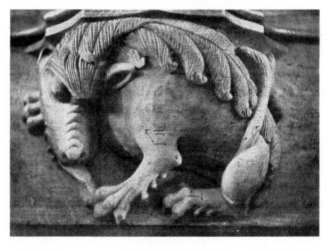

26. FAVERSHAM

Bestiary Wolf

and made away with the others while the mother stopped to comfort the rescued one. The more ingenious medieval writers suggested that the hunter should throw down mirrors or crystal balls, in which the tigress might see her own reflection, and, mistaking it for her cub, might try to suckle it and be deflected from her pursuit. This typified the good Christian diverted from good purposes by the shams of the world. Save for the misericord at Chester (fig. 23), and a boss at Queen Camel, Somersetshire, the hunter is omitted and the tigress appears alone, staring into the mirror (fig. 24). Heraldically the tigress and mirror is the badge of the Sybill family of Little Mote, Kent.

Wolf. The female wolf was supposed to give birth only in the month of May during a thunderstorm; a creature born under such stormy auspices could hardly fail to be savage and the wolf is described as greedy and bloodthirsty. It was clever in pursuit of prey, but capable of living on wind if food failed it. When it approached a sheepfold it licked its feet to make them tread softly, and if a twig snapped the offending foot was sharply bitten. This biting or licking of the feet is the characteristic most commonly represented by the carvers. The misericord at Faversham, Kent (fig. 26), probably represents one of the maned wolves of every colour which the *Bestiaries* tell us are to be found in Ethiopia. All wolves were not however wicked, for the legend of St Edmund tells how, after the King's execution by the Danes, a faithful wolf kept watch over his head

all night, until his followers came to give it burial. As King of East Anglia the cult of St Edmund was naturally popular in the Eastern counties and there are several carvings like the one at Walpole St Peter, Norfolk (fig. 25), showing a pleasant, dog-like creature holding a crowned head between its paws.

BIRDS

Symbolically the most important bird found in carving is the Dove, symbol of the Holy Ghost, but with the exception of a few bosses it is never shown alone, and its iconography varies little in place or time. The differences of species among native wild birds are not sufficiently marked to enable them to be recognized in spite of the conventionalization of sculpture, even if the carvers troubled to represent them, which is improbable, and we shall find that most of the recognizable birds are mythical or exotic.

Barnacles. The barnacle, or bernacle goose was supposed to originate in the shelly fruit of a tree from which it fell when fully fledged. If the young birds fell on land they perished, but if into water they were saved, thus typifying the benefits of Baptism. One of the corbels on the outside of Kilpeck Church, Herefordshire, represents two small birds hanging from, or holding up, a twig, and I should like to think that they were meant for barnacles, which otherwise are unrepresented in English sculpture.

Caladrius. A white bird, found chiefly in the courts of kings, which had the power of foretelling a sick

person's chances of recovery. If it looked away from him he was doomed, but if it gazed at him fixedly, with its beak almost touching his lips, it took all his sickness on to itself and then carried it up to the sun where it was dispersed again. It thus symbolized the Ascension of Christ, who carried the load of the world's sins up to Heaven. The only certain example carved in England is on the doorway at Alne, Yorks. (fig. 20).

Cock and hen. The cock symbolizes vigilance, for obvious reasons, and liberality because it calls its hens to share in any discovery of food (Wells Cathedral—misericord). The *Physiologus* says a white cock is feared by the lion because it symbolizes the men of holy life who foretold the fate of Christ and because it tells the hours of service in honour of St Peter. Pliny says that the fat of a cock smeared on a man's skin will keep him safe from the attacks of lions and panthers, while the raw, warm flesh of a newly killed bird will draw the venom from a snake bite. When shown standing on a globe the cock is the rebus of John Alcock, bishop of Ely (Ely Cathedral, Chantry Chapel). The hen and chickens, which are comparatively rare, occur on a misericord at Beverley Minster.

Crane. Cranes were supposed to flock together when they wished to sleep and to appoint a sentinel who held a stone in his uplifted foot, so that, if he fell asleep, the sound of the falling stone should warn his fellows of their possible danger. The carver at Denston, Suffolk, evidently knew that a crane should hold its "vigilance", but not

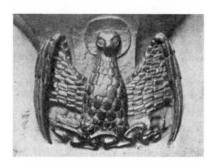

M.D.A. *page* 52

27. HIGHAM FERRERS
Eagle

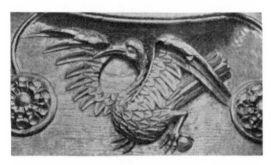

M.D.A. 28. DENSTON *pages* 50, 52
Crane

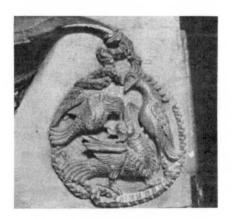

G. C. Druce 29. WINDSOR *pages* 53, 55
Hoopoes

the reason for it, as the bird is wide awake and crouching down (fig. 28). Aesop's fable of the fox and the crane is sometimes illustrated (Holt, Worcs.—door).

Doves. The design of doves drinking from a chalice symbolizes the Holy Communion and has been used with this intent ever since the early days of the Christian era. On the font at Winchester Cathedral a cross rises from the chalice, to make clear this meaning. Doves pecking at a bunch of grapes have the same significance.

Duck. The unromantic duck did not appeal to the carvers' imagination nor did the authors of the *Bestiary* attribute to it any symbolical habits, but it is sometimes to be met with on bench-ends (Stonham Aspal, Suffolk) and misericords.

Eagle. The eagle was thought to renew its youth by flying up towards the sun until its old plumage and the film over its eyes were burnt away, and then by diving into a fountain. A bench-end, built into the altar at Forrabury, Cornwall, shows a bird of prey diving into water and another flying; this may represent the eagle's rejuvenation or the fishing eagle, which typifies Christ seizing His elect out of the world. The misericord at Higham Ferrers, Northamptonshire (fig. 27), seems to show the eagle rising from water with a halo behind its head. The eagle was said to beat its young in order to make them fly and to force them to gaze upon the sun; a fledgling which blinked was cast out as unfit to rear. This characteristic led to the use of the eagle as the symbol of St John the Evangelist (see p. 6) and

it is therefore represented very frequently on tympana,
fonts, etc., with or without the figure of the saint. When
it appears alone it often holds a scroll. When used without
any symbolical meaning the eagle is difficult to distinguish
from the hawk (fig. 20).

Hawk. The symbolical meanings attached to the hawk
are rather confusing. Rabanus Maurus likens it to per-
sons who seem to be gentle and good and yet are in league
with wicked men, for the hawk, when tamed, is gentle
yet helps in plundering other birds. Its courage in
attacking its prey was supposed to resemble that of a holy
man laying violent hands upon the kingdom of God;
its return to the lure after a flight, a monk returning to
his convent after a journey into the world; while its
fetters denoted the mortifying of the flesh by a monastic
life. These subtleties cannot be illustrated in sculpture,
and the hawk always appears either alone, or holding
its prey (London, Victoria and Albert Museum—miseri-
cord). Hawking scenes are sometimes included in the
calendars as the appropriate occupation for the month
of May, as on a misericord at Ripple, Worcestershire,
and on the leaden font at Brookland, Kent.

Hoopoe. Guillaume le Clerc tells us that "the hoopoe
is a horrid bird, its nest is not nice and clean but is made
of mud and filth". The young birds, however, have
pleasant dispositions and tend their parents, when they
grow old and feeble, licking their eyes and plucking out
the old feathers to enable them to renew their youth.
This process is shown on a misericord at Carlisle Cathedral

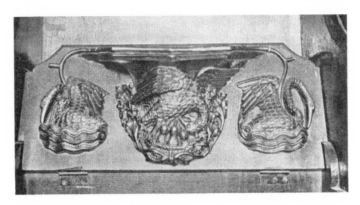

M.D.A pages 59, 60

30. LONDON, ST KATHERINE'S HOSPITAL
Pelican and Swans

G. C. Druce ## 31. NORWICH CATHEDRAL page 56
Owl mobbed by small birds

and on the stalls at Windsor (fig. 29); a hoopoe tending
its eggs appears on a bench at Great Gransden, Hunting-
donshire. The *Bestiaries* tell that, if a man smear himself
with the blood of a hoopoe before going to sleep, he will
dream that he is being suffocated by demons.

Ibis. These birds lived by the side of water and fed
upon carrion, which they found cast up on the shore,
for they could not swim and therefore did not dare to
enter deep water where clean food was to be had. In
this way the ibis typified men who dare not leave their
sinful life to gain grace. On a misericord at Lavenham,
Suffolk, a pair of these birds are shown pecking at the
head of a corpse. The other characteristic of the ibis,
according to the *Bestiaries*, is that it feeds its young
ones on serpents; birds shown with snakes held in their
beaks, as for instance on misericords at Windsor, are
likely to represent the ibis (fig. 32). One of these birds
is web-footed to indicate the nature of its habitat.

Ostrich. On misericords at Stratford-upon-Avon and
Windsor, ostriches are shown with horse-shoes in their
beaks, in illustration of their reputedly marvellous powers
of digestion. In both places the bird's feet have given
trouble, being either cloven or hooved. The carvers'
carelessness must not be blamed for this since the text
of the *Bestiaries* informed them that ostriches had feet
like a camel's, and the illuminations show them as
dumpy birds not unlike owls. The other characteristic of
the ostrich (not shown in sculpture) was that it gazed
steadily at the sky, and when the star Virgilia appeared

(in June) knew that it was time to lay its eggs. The bird then deserted its eggs leaving them to be hatched by the warmth of the sun, and it was honoured as the type of the man who abandons all earthly cares in favour of spiritual meditation. The *Speculum Humanae Salvationis* draws a parallel between the rescue of Daniel from the lions' den and the story of King Solomon, who procured a certain worm, which could cut glass or stone, by imprisoning young ostriches in a glass vessel and seizing the worm which the parent bird then brought in order to deliver them. On the same misericord as the ostrich at Windsor there is a bird with a serpent in its beak, but as the captive young are not shown it is more probably meant for an ibis (fig. 32).

Owl. Far from being regarded as the bird of wisdom, the owl was made the symbol of perverse foolishness, and since it prefers to hunt by night and is blinded by the light of day, it symbolized the Jews, wilfully preferring the darkness of their unbelief. The carvers, however, show more direct observation of nature than is customary with them when they represent the owl, for it is shown either brooding alone, with a mouse in its beak, or mobbed by small birds. Observation and symbolism were reconciled by making the mobbed owl typify the fate of sinners who were mocked by the righteous when their ill deeds came to light (fig. 31). On the stalls of Lincoln both the short- and long-eared owls are shown, the former appearing again on a misericord at Hemington, Northamptonshire, and the latter at

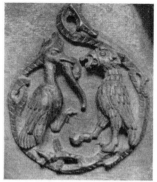

G. C. Druce *pages 55–6*

32. WINDSOR
Ibis and Ostrich

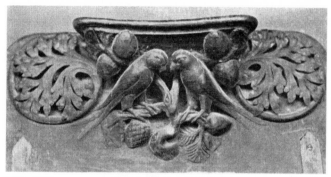

Phillips, Wells ### 33. WELLS CATHEDRAL *page 58*
Parrots

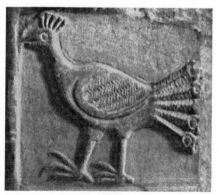

M.D.A. ### 34. HODNET *page 58*
Peacock

Edlesborough, Buckinghamshire. A curious misericord in Wells Cathedral represents an owl in the grasp of an ape; this, and the repetitions of the subject on a misericord at Winchester and painted on the ceiling at Peterborough are perhaps intended as satires on hawking.

Parrot. The *Bestiaries* had little to say about the parrot except that its head was so hard that it could be hit with an iron bar without suffering any ill effects. Solinus states that the difference between well- and ill-bred parrots is marked by the fact that the former have five toes, the latter only three (fig. 33). This became six and three in the French version, the better parrot standing for the good man who takes care not to sin. They are rare in carving.

Peacock. The peacock was sacred to Juno and associated with the Roman empresses who were deified at death; thus the bird came to represent immortality, The *Bestiaries* say that its flesh is so hard that it defies corruption. The eyes in its tail typified man's foresight, which he sometimes loses, or fails to use, as a peacock loses its tail. Its habit of dropping its tail suddenly was attributed to shame at the ugliness of its feet, as a man in the midst of worldly pomp may suddenly feel ashamed of his sin. A long-necked, crested bird with a bushy tail examining one of its feet is carved on a bench-end at Stogursey, Somersetshire. When the peacock cried in the night it was supposed to be terrified of losing its beauty, as a good Christian fears to fall from grace (Hodnet, Shropshire—font, fig. 34).

Pelican. The pelican feeding her fledglings with blood from her own breast (fig. 30) is the symbol of Christ's self-sacrificing love for his Church and was one of the favourite designs of the medieval carvers. A less creditable version of the legend tells that the growing birds peck their parent, who kills them in a fit of irritation. Having killed them she repents and brings them back to life by her own blood. The two stages of this story are perhaps illustrated on a misericord in Lincoln Cathedral, of which one supporter shows a pelican(?) pecking a small bird in the neck while the central subject is the conventional pelican. The real appearance and habits of the pelican were unknown to the carvers, who idealized its form in every instance. The nearest approach to reality is on the south door of St Austell. The legend may be derived from the bird's habit of pressing its beak (which has a red spot on it) against its breast in order to bring up the half-digested fish on which it feeds its young. The term "pelican in her piety" is the heraldic title and should not be applied to the *Bestiary* examples.

Phoenix. According to the legend there was never more than one phoenix in existence. After living for 500 years the unique bird felt the approach of age and, having loaded its wings with spices, it then flew from India to Heliopolis. The priest in the temple knew by some sign of its coming and laid a fire upon an altar. The bird fanned the flames with its wings and then mounted the altar and was consumed. From the ashes a worm was generated which gave out a sweeter smell

than any rose and in three days this developed into a full, perfect phoenix, which bowed to the priest and flew away for another 500 years of life. This legend symbolized the Resurrection. The Emperor Heliogabalus caused his empire to be scoured for the phoenix which he wished to eat, and was eventually contented with what was probably a Bird of Paradise. The appearance of the phoenix was never described in detail so that, unless it is shown in the midst of flames (Westminster, King Henry VII's Chapel—misericord), it can only be tentatively identified by the splendid ramifications of its tail.

Raven. The raven's habit of pecking out the eyes of animals is illustrated on a misericord at Ely depicting the Flood. It was supposed to desert its nest, not recognizing the naked fledgelings for its own, but the brood were saved from starvation by manna falling from Heaven.

Swan. Bartholomaeus Anglicus says of the swan "he singeth sweetly for he hath a long neck, diversely bent to make divers notes", but suggests no moral to be drawn. Heraldry added to the popularity of the graceful bird, for a swan was used as the badge of the Bohuns and others. Swans shown "ducally gorged" (fig. 30) are probably copied from such devices.

FISHES

Although a fish was used in early Christian art as the symbol of Christ and also of Baptism, it is not often represented on fonts in England, and when it occurs is generally only of subsidiary interest (fig. 9). The two

M.D.A. 35. ASHWELL *page* 63
Dolphin

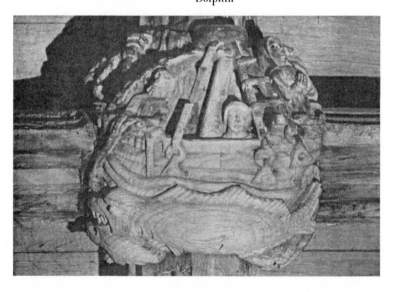

C. J. P. Cave 36. QUEEN CAMEL *page* 62
Aspido Chelone

fishes of the Zodiac are fairly common, especially upon Norman doors. Slight differences of species are rarely, if ever shown, and most of the fishes in medieval carving are based on one of the following four types.

Aspido Chelone. A sea monster much confused with *Balena* the Whale. Because no one knew what it was like it was drawn as a big fish. It is the sea tortoise or turtle, κῆτος, in the Greek version of Jonah, and incorrectly translated as *pisces* in the Latin, and "whale" in the Authorized Version. Aspido has two distinguishing characteristics: (i) It sleeps floating on the surface of the sea for so long that bushes take root upon its back, and sailors, mistaking it for an island, anchor their ships to it. When they land and kindle a fire the monster awakes and dives down carrying ship and sailors to destruction (Queen Camel, Som.—boss). (ii) Its breath is so sweet that small fishes are attracted to its mouth and are swallowed, while larger and wiser fishes avoid it. The medieval naturalists characteristically prefer to seek an explanation of the whale's habit of swallowing only small fish in the wisdom of the large ones rather than in the structure of the whale's throat. In carving the first characteristic is rarely illustrated (fig. 36), but the swallowing of one fish by another was very popular with the carvers who, forgetting the legend, make both fishes of almost equal size (Lakenheath, Suffolk—bench-end).

Dolphin. Bartholomaeus Anglicus tells that the dolphin knows by smell if a shipwrecked mariner ever ate

dolphin's flesh; if so it devours him, but if not it carries him to land on its back fighting off all other fishes. The *Bestiaries* say that the dolphin gashes the tender stomachs of crocodiles with its saw-like crest, and that it is very susceptible to music. The influx of foreign designs in the early sixteenth century made the dolphin a popular element in conventionalized ornament (Kilk-hampton, Devon—bench-ends). As the badge of the Dauphin it had long been widely used in France. See also under *Siren* (fig. 35).

Sawfish or *Serra*. Described as a sea monster having great wings. When it catches sight of a ship it rises to the surface, spreads its wings and competes with the ship in sailing. After racing about 40 furlongs it becomes exhausted and gives up the contest. The sea represents the world, the ship, godly persons passing through it, and the sawfish those weaker souls who are always eager to begin good works, but lack perseverance to conclude them. An alternative description is given by Isidore of Seville, who does not mention the wings but says that the sawfish has a sharp crest with which it pierces the hulls of ships and sinks them. The manu-script illustrations of the sawfish differ greatly; one shows a dragon, another a wolfish creature with bat's wings, and the fishy element is hardly brought out at all. This divergence in the miniatures makes the identification of serras in carving at best tentative (? Bishop's Stortford, Essex—misericord).

FABULOUS CREATURES AND HUMAN MONSTROSITIES

Amphisbaena. This winged serpent, with a second head at the end of its tail, was known to the Greeks as a symbol of deceit, for Cassandra likens Clytemnestra to it. Being double-headed and, as its name implies, able to move in either direction, it was identified with men leading a double life. The *Bestiaries* do not dwell on the symbolism but describe its movements, the deadliness of its bite, and the fact that it can stand greater cold than any other serpent. The carvers were inclined to bestow the amphisbaena's characteristic tail-head upon any monster whose horrific qualities they wished to enhance, such as the basilisk at Stonham Aspal, Suffolk (fig. 37), St George's dragon on a boss at St Andrew's, Worcester, and others.

Asp. The asp was symbolic of wicked ways, for it was supposed to lay one of its ears to the ground and block the other with the tip of its tail, thus becoming deaf to the divine words. The asp is perfectly represented in this attitude on the pedestal between the main doors of Amiens Cathedral, but the English examples only bring their tails up over their backs, turning their heads slightly to meet them. This may be due to faithful, if uncomprehending copying of manuscript illuminations, for a *Bestiary* belonging to Corpus Christi College, Cambridge, shows the asp in such a position, but with a convenient mound in the background to which it applies its ear (Egloskerry, Cornwall—tympanum). Ac-

cording to Guillaume le Clerc the venoms of the different species of asps vary in their effects. One kind produces a killing thirst, another a death sleep, a third causes every vein to burst, and the fourth, and most fearful, causes instant disintegration, the victim's body falling to the ground as dust.

Basilisk or *Cockatrice*. This creature was said to be hatched from the egg of a seven-year old cock laid in a dung-hill and incubated by a toad. The fledgling had the head, feet and wings of a cock, but the body and tail of a reptile. From the moment of birth it hid, for while the basilisk's glance was fatal to man, the creature itself perished if human beings sighted it while themselves remaining unseen. The only safe way for a man to overcome the basilisk was for him to hold a crystal bowl before his face, so that its own lethal glance was thrown back upon the monster. Alone among animals the weasel could kill the basilisk, perhaps because, before advancing to the attack, it fortified itself by eating rue. The carvers show basilisks alone or confronting adversaries as monstrous as themselves; the weasel is denied its glory. The combination of amphisbaena and basilisk at Stonham Aspal, Suffolk (fig. 37), is probably of heraldic origin.

Blemyae. Pliny describes the Blemyae as a race of men having no heads, their eyes and mouths appearing in their breasts. The French versions of the *Romance of Alexander* add the information that they are six feet high and the colour of gold, with long beards which cover the lower part of their bodies. Clearly defined

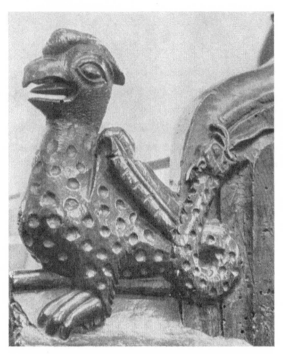

37. STONHAM ASPAL pages 64-5

Basilisk with Amphisbaena tail-head

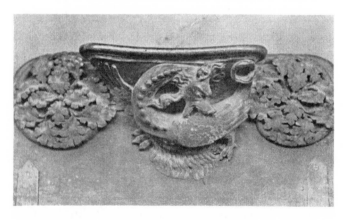

38. WELLS CATHEDRAL pages 71, 72

Salamander

examples are to be seen on misericords (Norwich (fig. 42) and Ripon Cathedrals), but in the cruder stone carvings it is hard to distinguish Blemyae from distorted figures of men sitting with their heads between their knees.

Brachmani. See under *Sciapod.*

Centaur. Unlike the majority of human composites the centaur has a very complicated symbolism. Its human half typifies Christ upon earth, the horse His vengeance upon the Jews for having betrayed Him. When shown shooting, the centaur's bow signifies that, when Christ was on the Cross and His body was struck, His soul departed to help those He loved who were waiting His deliverance in Hell. This explanation by Philippe de Thaun, far-fetched as it seems, accounts for the frequent representations of the Sagittarius aiming his arrow at the throat of a monster (fig. 40), as Christ thrusts His Cross into a dragon's mouth to represent the Harrowing of Hell (Kencot, Oxon.—tympanum). The female centaur is comparatively rare and has no particular symbolism (Iffley, Oxon.—south door).

Cyclops. Although the classical cyclops is mentioned in medieval travellers' tales, it does not appear in English sculpture, with the possible exception of a head on the exterior cornice of Adderbury Church, Oxfordshire.

Cynocephali. The supposed Fermes tells of a race of men with dogs' heads, and Friar John of Pian de Carpini, who travelled to the court of Kuyuk Khan in 1245–7, records as unquestioned fact that the Tartar armies had

fought against "monsters who in all things resembled men, saving that their feet were like the feet of an ox, and they had indeed men's heads but dogs' faces. These spoke as it were two words like men, but at the third they barked like dogs." The original version of the legend of St Christopher told that he was dog-headed. These ghastly hybrids are too fantastic to be distinguished with any certainty from meaningless grotesques (Bristol Cathedral—boss).

Dragon. The dragon is by far the commonest animal in carvings. It is the greatest of all serpents, the enemy of all good beasts such as the elephant and panther (q.v.). In the *Bestiaries* about twenty-five varieties of small serpents and other creatures are drawn in dragon-form which in carvings are, for the most part, indistinguishable, and only two variations from the normal type need be mentioned. The *Wyvern* is distinguished from the dragon by having only two legs. Both species have beast's heads, bat's wings and eagle's legs. The absence of hindlegs made the wyvern a more adaptable element in a design, and it is often substituted for the dragon even in combats with St George. The *Lyndworm* is a wingless wyvern and is very rarely carved (Limerick Cathedral—misericord).

Griffin. This fearsome hybrid, which symbolized the Devil in the French *Bestiary*, had the forepart of an eagle and the hindquarters of a lion, was supposed to live in India where gold abounded and to destroy the covetous persons who tried to seize this treasure. Sir

John Mandeville says that the griffin is stronger than eight lions and more stalwart than 100 eagles; that of its nails men made cups, and strong bows from the backs of its feathers. In carvings the griffin is generally shown carrying off its prey, which ranges from a rabbit (Ripon Cathedral—misericord) to a man (Nantwich, Cheshire—misericord), but sometimes the carvers were evidently confused as to the griffin's character and gave it a totally undeserved position. At Aston, Herefordshire (frontispiece), the carver has probably tried to combine the symbols of St John and St Mark, for the griffin appears on the tympanum as the most unsuitable supporter of the Agnus Dei. The other supporter is the winged bull of St Luke. It was early adopted as a heraldic device in England, appearing on the seal of the Earl of Exeter in 1167.

Hydrus. This was said to be a small serpent which covered itself in mud and then slipped into the throat of a sleeping crocodile whose side it burst asunder and thus escaped. This legend typified Christ who took human form, and descended into Hell and rescued the souls confined there. This episode is often called the Harrowing of Hell. The carvers show the hydrus' tail vanishing into the crocodile's mouth (Kilpeck, Heref.—gargoyles). The many-headed hydra of classical literature is only shown on a misericord in New College Chapel, Oxford, and here it plainly represents Evil headed by the Seven Deadly Sins, for the supporters illustrate penance and exorcism.

Mantichora. This fearful creation of human fantasy had the head of a grey-eyed man with three rows of

M.D.A. 39. EDLESBOROUGH *page* 73

Siren and Lion

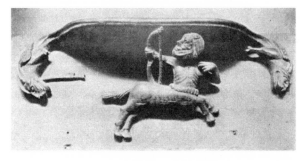

G. C. Druce 40. EXETER CATHEDRAL *page* 67

Sagittarius

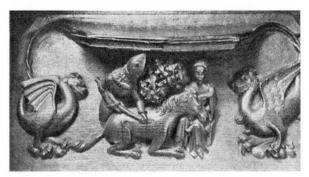

F. H. Crossley 41. CHESTER CATHEDRAL *page* 74

Capture of the Unicorn

teeth, the body of a lion and the tail of a scorpion. It
pursued and ate naked men (Meigle, Perthshire—sepul-
chral stone). Ctesias claimed to have seen one at the
court of Persia, but it has been pointed out that, as the
word used is "martichoras", a corruption of the Persian
for "man-eater", the animal was probably a tiger.
Human-headed quadrupeds are not uncommon in medieval
sculpture, but since the carvers seldom troubled about
accuracy of detail it is impossible to say how many of
these were intended to represent the mantichora (fig. 21).

Mermaid. See under *Siren.*

Pygmy. In the Westminster *Bestiary* a pygmy is
shown standing on a spray of foliage, and it is possible
that the small man standing on a leaf which is carved
on the font at Stone, Buckinghamshire (fig. 9), may have
been copied from a similar illumination.

Sagittarius. See under *Centaur.*

Salamander. This reptile, which was supposed to
live in fire, symbolized the man who could pass through
the fires of temptation unscathed. In appearance the
legendary salamander is a winged dragon with two legs,
three-toed feet, and a long tail which is always branched
or knotted. The intricate convolutions of its tail made
it popular with goldsmiths and its associations with
fire an appropriate decoration for the famous Gloucester
candlestick, and others. It is also frequently represented
on fonts (Salehurst, Sussex). The belief that the sala-
mander could extinguish fire goes back to classical

literature, and, in fact, there is a frog-like reptile with rows of tubercules in its sides which secrete a fluid capable of extinguishing a live coal. Marco Polo was one of the first to doubt the legend of the salamander and to suggest that the incombustible substance known as "salamander's wool" was a mineral found in Tartary—in fact asbestos (fig. 38).

Satyr. The medieval carver's conception of the satyr was confined to classical models and its form was adopted as a demon in Christian art. On the other hand it was also identified with the large ape, called "satyrus", recorded by classical authorities. The carver of the stalls at Lincoln has tried to combine both forms by planting ram's horns on the head of an orang-outang.

Sawfish or *Serra*. See under *Fish*.

Sciapod. Pliny says of the "sciapod", or shadow-foot, that he has "great pertinacity in leaping", but as this could not well be illustrated he is generally shown lying on his back with his one enormous foot held aloft to keep off the sun. In the only carving of a sciapod in England, at Dennington, Suffolk (fig. 43), the carver has made the mistake of giving him two feet. Under his arm are three small round objects, which Mr Druce identifies as the heads of the *Brachmani*, a tribe of small cave-dwellers, who are mentioned in the *Romance of Alexander* as imploring the Conqueror not to attack them since they had nothing worth taking. They are well shown in the Westminster *Bestiary* at the mouth of their cave.

Siren. There are two types of siren in art: the bird-siren and the fish-siren. Both lured sailors to their death by their sweet singing and in medieval art they merged into one, the fish type predominating. Transitional types, having feathers and claws as well as fish-tails, are sometimes found on misericords (Carlisle and Hereford, All Saints'). The fatal music is indicated on a misericord at Boston, Lincolnshire, where a mermaid, playing upon a pipe, is shown approaching two men in a boat. When the mermaid holds a fish in her hand she typifies the Evil One with a soul in his grasp (Exeter Cathedral—misericord), but this is comparatively rare, the carvers preferring to show the mirror and comb of legend. Curious carvings of mermaids suckling lions (fig. 39) occur on misericords (Norwich and Wells) and are probably derived from some manuscripts of which even Mr Druce knows no surviving example. Several mermaid misericords have dolphins as supporters (Ludlow, Salop). By comparison with the mermaid, single figures of the merman are very rare, but sometimes both sexes appear side by side (Stratford-upon-Avon).

Terrobuli or *Terrebolem.* These stones, in the form of a man and a woman, burst into flames when brought into contact with each other, thus illustrating the danger of men associating with women (Alne, Yorks.—door).

Unicorn. The "monoceros" of the *Bestiaries* (which was probably the rhinoceros) is described as a great beast with a terrible bellow, having the body of a horse, the feet of an elephant, the tail of a stag, and a horn

four feet long and so sharp that it pierced anything which it touched. It was too fierce to be captured, and so differed from the true unicorn, which, finding a virgin sitting in the forest, would lay its head meekly in her lap and fall a victim to the hunter (fig. 41), thus typifying the Incarnation and death of Christ. An alternative method of capturing the unicorn (Cartmel, Lancs.— misericord) was to induce the animal to charge, and then to dodge behind a tree, in the trunk of which the redoubtable horn became inextricably imbedded. As the symbol of Christ the unicorn appears fairly frequently on fonts (Norton, Suffolk) and misericords (Durham Castle). Sometimes it combats other animals—symbols of Evil. The unicorn's horn was supposed to have the property of detecting poison; and eminent persons, among others Queen Elizabeth, considered cups made from it as treasured possessions. These supposed horns of the unicorn, which were sold for immense sums, were actually narwhal tusks.

Wodewose or *Woodhouse*. The wild man of the woods was very popular with the carvers especially during the fourteenth and fifteenth centuries. Herodotus had told of wild men living in Lybia, and in some versions of the *Romance of Alexander*, a captured wild man is burnt at the stake because he had no understanding. So far he had been considered as half man half ape, akin to the satyr, but in medieval art he develops into a definite type, a bearded man, either hairy or clothed in skins, and generally contending with wild

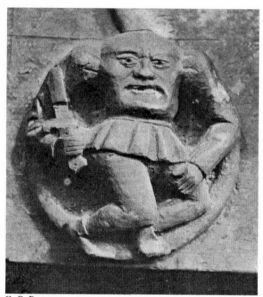

page 67

42. NORWICH CATHEDRAL

Blemya

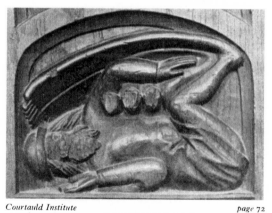

page 72

43. DENNINGTON

Sciapod

beasts. The romance of Valentine and Orson increased his popularity, and in Elizabethan pageants the wode-wose often featured as the sylvan spokesman. On the bases of East Anglian fonts he frequently alternates with lions (Halesworth and Framlingham, Suffolk).

Wyvern. See under *Dragon.*

Part III

LISTS OF EXAMPLES

The lists marked with an asterisk include only illustrations representative of the different legends connected with animals so common that a lengthy, but still incomplete, catalogue of each animal would have no value. The lists not so marked are as complete as I can make them.

In order to save space the word "cathedral" has been omitted and the carving should be assumed to be in the cathedral unless another church in the city is specified. The same rule has been applied to St George's Chapel, Windsor.

*AGNUS DEI: ADORED BY ANGELS OR MEN: *Tympana:* Langport, Som.; Tarrant Rushton, Dorset. ADORED BY OTHER ANIMALS: *Tympana:* Hognaston, Derbys.; Parwich, Derbys.; Pen Selwood, Som. FIGHTING THE DRAGON: *Capital:* York, St Lawrence-extra-Walmgate. SURROUNDED BY VINE, *Boss:* Bremhill, Wilts.

AMPHISBAENA: *Capitals:* Burton Dassett, Warwicks.; Canterbury, crypt; Lathbury, Bucks.; Newton Longville, Bucks. *Fonts:* Hook Norton, Oxon.; Laneast, Corn.; Lincoln; Luppitt, Devon. *Bosses:* Queen Camel, Som.; Selby Abbey, Yorks.; Sherborne, Dorset; Southwark Cathedral (detached); Worcester, St Andrew's. *Stalls and benches:* Bristol; Stonham Aspal, Suff.; Swavesey, Cambs. *Misericords:* Edlesborough, Bucks.; Godmanchester, Hunts.; Hemington, Northants.; Lavenham, Suff.; Limerick; Windsor. *Screens:* Conway, Carnarvon; Llanano, Radnors.

*ANTELOPE (NATURAL): *Corbel:* Tring, Herts. *Font:* Alphington, Devon. *Boss:* Queen Camel, Som. *Stalls and benches:* Bury St Edmunds; Denston, Suff.; Eynesbury, Hunts.; Sefton, Lancs.; Walpole St Peter, Norf. *Misericords:* Manchester; Norwich; Ripon. (HERALDIC): *Cornices:* Cirencester, Glos.; London, Westminster Abbey. *Font:* Southfleet, Kent. *Stalls and benches:* Faversham, Kent; King's Lynn, St Nicholas'; Wensley, Yorks.; Wiggenhall St German, Norf. *Misericords:* Canon Pyon, Heref.; Limerick; Minster-in-Thanet, Kent; Ripon; Windsor.

*APE: *Tympanum:* Stanley St Leonard, Glos. *Buttress:* Tiverton, Devon (female ape with young). *Bosses:* Bristol, St Mary Redcliffe; Norwich, cloisters; Selby (2). *Stalls and benches:* Brent Knoll, Som.; Combe-in-Teignhead, Devon (2); Halton Holgate, Lincs.; Sall, Norf.; Southwold, Suff.; Tostock, Suff.; Winchester, Lady Chapel; Windsor; Woolpit, Suff. *Misericords:* Beverley Minster and St Mary's; Bristol; Boston, Lincs.; Cartmel, Lancs.; Faversham, Kent; Gamlingay, Cambs.; Godmanchester, Hunts.; Manchester; Norwich; Stratford-upon-Avon; Wells; Winchester; Windsor.

ASP: *Doors:* Egloskerry, Corn.; Ely (?). *Choir arcade:* Worcester. *Misericords:* Chichester; Exeter.

ASPIDO CHELONE and WHALE: *Door:* Alne, Yorks. *Boss:* Queen Camel, Som. *Stalls and benches:* Great Gransden, Hunts.; Isleham, Cambs.; Kidlington, Oxon.; Lakenheath, Suff.; St Levan, Corn. *Misericords:* Norwich; Ripon; Sall, Norf.

BARNACLE GOOSE: *Corbel:* Kilpeck, Heref. (?).

BASILISK: *Doors:* Dalmeny, West Lothian; Lullington, Som. *Boss:* Queen Camel, Som. *Stalls and benches:* Beverley Minster; Stonham Aspal, Suff.; Stowlangtoft,

Suff.; Tostock, Suff.; Upper Sheringham, Norf. *Miseri-cords:* Carlisle; Exeter; Lincoln; London, Henry VII's Chapel; Malvern, Worcs.; Nantwich, Ches.; Windsor.

BAT: *Stall:* Sudbury, Suff., St Gregory's. *Misericords:* Chichester; Christchurch, Hants.; Dunblane, Perthshire; Edlesborough, Bucks.; Herne, Kent; Lincoln; Wells.

*BEAR: *Doors:* Barfreston, Kent; Moccas, Heref.(?). *Corbel:* Kilpeck, Heref. *Stalls and benches:* Lincoln; Manchester; Stonham Aspal, Suff.; Stowlangtoft, Suff.; Winchester; Windsor. *Misericords:* Beverley Minster; Durham Castle; Stratford-upon-Avon. BEAR AND RAGGED STAFF: *Fonts:* Holt, Denbighs.; Shipton-under-Wychwood, Oxon. *Tower:* Lechlade, Glos. *Stalls and benches:* Coventry; Rettendon, Essex; Warwick.

BEAVER: *Stalls:* Windsor (?).

BLEMYA: *Door:* Barfreston, Kent (?). *Cornice:* Adderbury, Oxon. (?). *Misericords:* London, V. and A. Museum; Norwich; Ripon.

*BOAR: *Doors:* Ashford, Derbys.; Ely; Hognaston, Derbys.; Little Langford, Wilts.; Clifton Hampden, Oxon. (detached tympanum); Ipswich, St Nicholas'; Parwich, Derbys. *Fonts:* Holt, Denbighs. (heraldic); Hull, Holy Trinity. *Boss:* Selby Abbey. *Stalls and benches:* Bradford Abbas, Dorset; Stowlangtoft, Suff. (2, one playing a harp). *Misericords:* Beverley, St Mary's; Malvern, Worcs.; Windsor.

CALADRIUS: *Doors:* Alne, Yorks.; York, St Margaret Walmgate (?).

CAMEL: *Tomb:* Glastonbury, Som. *Boss:* Queen Camel, Som. *Stalls and benches:* Eynesbury, Hunts.; Isleham, Cambs.; Nantwich, Ches.; Sefton, Lancs.;

Stowlangtoft, Suff. (3); Swaffham Bulbeck, Cambs.;
Tostock, Suff.; Ufford, Suff.; Walpole St Peter, Norf.
Misericords: Beverley Minster; Boston, Lincs.; Faversham, Kent; Lincoln; Manchester; Ripon; Stratford-upon-Avon.

CAT: Capitals: Northleach, Glos., porch; York,
Chapter House. *Fonts:* Hodnet, Salop; Kirkburn, Yorks.
Stalls and benches: Boston, Lincs.; South Lopham,
Norf.; Stowlangtoft, Suff.; Tuttington, Norf.; Upper
Sheringham, Norf.; Woolpit, Suff. *Misericords:* Beverley Minster; Boston, Lincs.; Bristol; Godmanchester,
Hunts.; Hereford; Malvern; Winchester.

CATTLE: WINGED BULL: Tympanum: Pedmore, Worcs. *Fonts:* Aylsham, Norf.; Halesworth,
Suff.; Hart, Durham; Haughley, Suff. *Misericord:*
Cockington, Devon. MILKING: *Misericord:* Beverley
Minster; *Watching loft:* St Albans. OX BEING
SLAUGHTERED: *Misericords:* Malvern, Worcs.;
Worcester. BULL: *Misericord:* Bampton, Oxon.

CENTAUR: Doors: Dalmeny, West Lothian; Kencot, Oxon.; Salford, Oxon.; Stoke-sub-Hamdon, Som.
Capitals: Beckford, Glos.; Durham, Chapter House;
Iffley, Oxon. *Fonts:* Darenth, Kent; Dunkeswell, Devon;
Hook Norton, Oxon. *Bosses:* Beverley Minster; Bristol;
Gloucester (2); Peterborough. *Stall:* Ripon. *Misericords:* Ely; Exeter (2).

COCK and HEN: *Capitals:* Rowlestone, Heref. (2);
Cambridge, Great St Mary's; Ely, Chantry Chapel.
Stalls and benches: Cambridge, Jesus Chapel; Great
Gransden, Hunts.; Grimston, Norf.; Ickleton, Cambs.;
Lincoln; Tostock, Suff.; Wiggenhall St Mary, Norf.
Misericords: Beverley Minster; Ripon; Tewkesbury,
Worcs.; Wells.

CRANE: *Doors:* Barfreston, Kent; Holt, Worcs. *Misericords:* Chester; Denston, Suff.; Lincoln.

CROCODILE: *Doors:* Bradbourne, Derbys.; Great Rollright, Oxon. (?). *Fonts:* Ilam, Staffs.; Stone, Bucks.; Tissington, Derbys.; Topsham, Devon. *Stone slab:* Holton, Suff. *Figure on parapet:* Yaxley, Hunts. *Stalls and benches:* Bristol; Great Walsingham, Norf. *Misericords:* Chichester; Edlesborough, Bucks. See also under *Hydrus.*

CYCLOPS: *Cornice:* Adderbury, Oxon. (?).

CYNOCEPHALI: *Boss:* Bristol. *Bench:* Ufford, Suff. *Misericords:* London, V. and A. Museum; Malvern (?).

DEER. See HART.

*DOG: *Bosses:* Exeter; Sherborne, Dorset. *Font:* Lostwithiel, Corn. *Stalls and benches:* Lakenheath, Suff.; Stevington, Beds.; Stonham Aspal, Suff.; Winthorpe, Lincs.; Woolpit, Suff. *Misericords:* Christchurch, Hants.; Southwold, Suff.; Winchester; Windsor.

DOLPHIN: *Bosses:* Gloucester, nave; Selby Abbey. *Stalls and benches:* Ashwell, Herts.; Kilkhampton, Devon; Monksilver, Som.; Sparsholt, Berks.; Stanground, Hunts.; Swaffham Bulbeck, Cambs. *Misericords:* Beverley Minster; Etchingham, Sussex; Gloucester; Ludlow, Salop; Minster-in-Thanet, Kent; Nantwich, Ches.; Norwich. *Screen:* Lavenham, Suff.

DOVES: *Boss:* Sherborne, Dorset. *Stone slab:* Bishopstone, Sussex. *Font:* Winchester. *Stalls and benches:* Godmanchester, Hunts.; Westwell, Kent. *Misericords:* Ripon; Wells.

*DRAGON: FIGHTING THE ELEPHANT: *Font:* Dunkeswell, Devon. *Misericord:* Carlisle. FIGHTING THE PANTHER: *Door:* Alne, Yorks. *Stone slab:*

Newton, Yorks. FIGHTING ST GEORGE: *Tympana:*
Brinsop, Heref.; Linton, Roxburghs.; Ruardean, Glos.
Boss: Worcester, St Andrew's. *Misericords:* Lincoln;
Norwich; Windsor; Worcester. FIGHTING ST
MICHAEL: *Tympana:* Hallaton, Leics.; Hoveringham,
Notts.; Ipswich, St Nicholas'; Moreton Valence, Glos.

DUCK: *Bench:* Stonham Aspal, Suff. *Misericord:*
Stratford-upon-Avon (?).

*EAGLE: SYMBOL OF ST JOHN: *Tympana:* Elk-
stone, Glos.; Rochester. *Fonts:* Aylsham, Norf.; Castle
Frome, Heref.; Norton, Suff.; Stoke-by-Nayland, Suff.
RENEWING ITS YOUTH: *Door:* Alne, Yorks.
Pulpit: Forrabury, Corn. *Misericord:* Higham Ferrers,
Northants. (?). DOUBLE-HEADED: *Bench:* Great Mas-
singham, Norf. *Misericords:* Boston, Lincs.; Whalley,
Lancs.; Worcester. WITH PREY: *Capital:* Ribbesford,
Worcs. *Misericords:* Norwich; Stratford-upon-Avon;
Wells; Worcester.

EALE: *Gateways:* Cambridge, Christ's College and
St John's College. *Tomb:* Westminster Abbey, Hunsdon
monument. See also under ANTELOPE (HERALDIC).

ELEPHANT: *Capital:* Ottery St Mary, Devon. *Font:*
Dunkeswell, Devon. *Bosses:* Canterbury, cloisters;
Queen Camel, Som.; Selby Abbey. *Stalls and benches:*
Chester; Oxburgh, Norf.; Ripon; Willian, Herts.
Misericords: Exeter; London, St Katherine's Hospital;
Tewkesbury, Worcs.; Windsor (2).

*FOX: LURING THE BIRDS: *Door:* Alne, Yorks.
Misericords: Chester; Nantwich, Ches.; Whalley,
Lancs. EXECUTION OF: *Tomb:* London, St Katherine's
Hospital. *Bench:* Brent Knoll, Som. PREACHING:
Benches: Brent Knoll, Som.; Osbournby, Lincs.; Stow-
langtoft, Suff. *Misericords:* Boston, Lincs.; Bristol;

Ely; Gresford, Denbighs. FOX AND STORK (Aesop's fable): *Capital:* Holt, Worcs. *Misericord:* Chester. CARRYING OFF GOOSE: *Stalls and benches:* Boston, Lincs.; South Burlingham, Norf.; Woolpit, Suff. *Misericords:* Ely; Fairford, Glos.; Norwich; Whalley, Lancs.

FROG: *Doom-stone:* York. *Boss:* Norwich, cloisters. *Stalls:* Gloucester; Lincoln. *Misericords:* Edlesborough, Bucks.; Windsor.

GOAT: *Doors:* Alne, Yorks.; Ely. *Capitals:* Adel, Yorks.; Southwell, Chapter House. *Boss:* Norwich, cloisters. *Benches:* Cawston, Norf.; Eynesbury, Hunts. *Misericords:* Gloucester; Newark, Notts.; Stratford-upon-Avon; Winchester College; Worcester.

*GRIFFIN: *Tympana:* Aston, Heref.; Ridlington, Rutland. *Fonts:* Bungay, Suff. (piscina); Kelsale, Suff.; Norton, Suff.; Risby, Suff. *Stalls and benches:* Ashwell, Herts.; Bury, Lancs.; Christchurch, Hants.; King's Lynn, St Nicholas'. *Misericords:* Chester; Darlington, Durham; Lincoln; Wells; Whalley, Lancs.

*HART: FIGHTING THE DRAGON OR SERPENT: *Door:* Dalmeny, West Lothian. *Font:* Melbury Bubb, Dorset. *Bench:* Forrabury, Corn. *Misericord:* Ely. ST HUBERT OR ST EUSTACE LEGEND: *Boss:* Norwich, cloisters. *Bench:* Winthorpe, Lincs. ST GILES LEGEND: *Cornice:* Adderbury, Oxon. *Misericord:* Ely.

*HAWK: HAWKING SCENES: *Fonts:* Brookland, Kent; Lostwithiel, Corn. *Misericords:* Beverley Minster; Ripple, Worcs.; Worcester. HOLDING PREY, OR ALONE: *Misericords:* Edlesborough, Bucks.; London, V. and A. Museum; Wells.

HEDGEHOG: *Door:* Barfreston, Kent. *Tomb:* Childrey, Berks. *Misericords:* Cartmel, Lancs.; Oxford, New College.

HIPPOPOTAMUS: *Bench:* Eynesbury, Hunts. *Misericord:* Windsor.

HOOPOE: *Benches:* Great Gransden, Hunts.; St Levan, Corn. (?). *Misericords:* Carlisle; Windsor.

*HORSE: WITH JOUSTING OR FIGHTING KNIGHTS: *Doors:* Barfreston, Kent; Fordington, Dorset. *Misericords:* Gloucester; Lincoln; Worcester. HORSES ALONE: *Benches:* Eynesbury, Hunts.; Stowlangtoft, Suff.; Swavesey, Cambs. *Misericord:* Faversham, Kent.

HYDRUS: *Gargoyles:* Bury St Edmunds, Suff.; Kilpeck, Heref. *Font:* Stone, Bucks. *Stalls:* Bristol. *Misericord:* Chichester (?).

HYENA: *Doors:* Alne, Yorks.; Barton Segrave, Northants.; Bradbourne, Derbs. (?). *Capitals:* Alton, Hants.; Kilpeck, Heref. (corbel). *Font:* Ilam, Staffs. *Boss:* Queen Camel, Som. *Misericord:* Carlisle.

IBEX: *Stall:* King's Lynn, St Nicholas'.

IBIS: *Corbel:* Kilpeck, Heref. *Boss:* Bristol. *Bench:* Llanynis, Denbighs. (?). *Misericords:* Lavenham, Suff.; Windsor (2).

*LION: BRINGING CUBS TO LIFE: *Boss:* Canterbury, cloisters. FIGHTING THE DRAGON: *Tomb:* Beverley Minster. *Bench:* Diddington, Hunts. *Misericords:* London, St Katherine's Hospital; Manchester. FIGHTING WITH SAMSON: *Tympana:* Highworth, Wilts.; Stretton Sugwas, Heref. *Door:* Malmesbury, Wilts. *Misericords:* Beverley, St Mary's; Ely; Norwich. SYMBOL OF ST MARK: *Fonts:* Aylsham, Norf.;

Helmingham, Suff.; Little Waldingfield, Suff. *Bench:*
Ketton, Northants. FINE SINGLE LIONS: *Fonts:*
Eardisley, Heref.; Shobdon, Heref. *Misericords:* Wells
(2).

LIZARD: *Corbel:* Wells. *Font:* Stone, Bucks. *Stalls:*
Gloucester.

MANTICHORA: *Doors:* Dalmeny, West Lothian;
Fishlake, Yorks. (?); Kilpeck, Heref. *Incised stone:*
North Cerney, Glos. *Tombstone:* Meigle, Perthshire.
Cornice: Denston, Suff. (?). *Boss:* Queen Camel, Som.

OSTRICH: *Misericords:* London, Henry VII's
Chapel (?); Stratford-upon-Avon; Windsor.

OTTER: *Misericord:* Windsor.

OWL: *Chantry chapel roof:* Exeter. *Capital:* Lin-
coln. *Bosses:* Norwich, cloisters (2); Sherborne,
Dorset. *Stalls and benches:* Godmanchester, Hunts.;
Halton Holgate, Lincs.; Higham Ferrers, Northants.;
Lincoln; Osbournby, Lincs.; Stowlangtoft, Suff.; Strat-
ford-upon-Avon. *Misericords:* Beverley Minster; Bishop's
Stortford, Essex; Edlesborough, Bucks.; Ely; Ludlow,
Salop; Norwich (2); Wells.

PANTHER: *Door:* Alne, Yorks. *Slab:* Newton,
Yorks. *Font:* Melbury Bubb, Dorset (?).

PARD: *Tympanum:* Pen Selwood, Som. *Capitals:*
Canterbury, crypt; Newton Longville, Bucks. *Fonts:*
Hodnet, Salop; Holbeton, Devon; Hook Norton, Oxon.;
Ipswich, St Peter's; Newenden, Kent; St Stephen-in-
Brannell, Corn. *Misericords:* Malvern; Windsor.

PARROT: *Benches:* Great Gransden, Hunts.; Stow-
langtoft, Suff. *Misericords:* Wells; Windsor.

PEACOCK: *Cornice:* Adderbury, Oxon. *Door:* Malmesbury, Wilts. *Saxon stone:* Rous Lench, Glos. *Boss:* Canterbury, cloisters (heraldic). *Stalls and benches:* Bristol; Nantwich, Ches.; Stogursey, Som. (?). *Misericords:* Cartmel, Lancs.; Durham; Lincoln; Oxford, New College; Wells.

*PELICAN: Iconography hardly varies; particularly beautiful examples on misericords at Lincoln; Whalley, Lancs.; Wells.

PHOENIX: *Doors:* Dalmeny, West Lothian; Kilpeck, Heref. *Font:* East Haddon, Northants. *Bosses:* Exeter; Queen Camel, Som. *Misericord:* London, King Henry VII's Chapel.

*PIG: HOGS FEEDING: *Stall:* Little Malvern. *Misericords:* Lincoln; Malvern; Worcester. SOW AND FARROW: *Bosses:* Bristol, St Mary Redcliffe; Exeter (2); Spreyton, Devon; Ugborough, Devon. *Misericords:* Chester; Worcester. PLAYING MUSICAL INSTRU-MENTS: *Misericords:* Beverley Minster; Durham Castle; Manchester; Ripon. *Pulpit:* Ribbesford, Worcs.

PYGMY: *Font:* Stone, Bucks.

RABBIT: *Door:* Ely. *Corbel:* Kilpeck, Heref. *Cornice:* Thaxted, Essex. *Bosses:* Lincoln, cloisters; Selby Abbey, Yorks. *Stalls and benches:* Balderton, Notts.; Bristol; Hereford, All Saints'; Little Saxham, Suff. *Misericords:* Wells; Winchester.

RAVEN: *Stalls:* Bristol. *Misericord:* Ely.

SALAMANDER: *Boss:* Sherborne, Dorset. *Fonts:* Alphington, Devon; Bridekirk and Dearham, Cumber-land; Haddenham, Bucks.; Norton, Derbs.; St Austell, Corn.; Salehurst, Sussex; Sculthorpe, Norf.; Studham,

Beds.; Winchester; Youlgreave, Derbys. *Stalls and benches*: Chedzoy, Som.; Mawgan Pyder, Corn.; Windsor. *Misericord*: Wells.

SATYR: *Stalls*: Lincoln. *Misericords*: Chichester, Cathedral and St Mary's Hospital.

SAWFISH or SERRA: *Doors*: Dalmeny, West Lothian (?); Netherton, Worcs. (removed). *Misericord*: Bishop's Stortford, Essex.

SCIAPOD: *Bench*: Dennington, Suff.

SERPENT: *Door*: Newton Purcell, Bucks.; Teversall, Notts. *Corbel*: Bletchingley, Surrey. *Rafter*: Hereford, cloisters. *Fonts*: Ashford-in-the-water, Derbys.; Laneast, Corn.; Little Hinton, Wilts.; Kirkburn, Yorks. *Bench*: Horning, Norf.

*SHEEP: *Door*: Barfreston, Kent (butting rams). *Capital*: Hereford. *Corbel*: Winchester. *Benches*: Altarnon, Corn.; Swavesey, Cambs.; Tostock, Suff. *Misericords*: Beverley Minster; Ely; Norwich; Over, Cambs.; Oxford, New College; Winchester, Cathedral and College.

*SIRENS: BIRD-SIRENS: *Corbel*: Bristol, cloisters. *Misericords*: Exeter; Lincoln; Oxford, New College. TRANSITIONAL TYPES: *Boss*: Selby Abbey, Yorks. *Misericords*: Carlisle; Nantwich, Ches. MERMEN: *Boss*: Queen Camel, Som. *Fonts*: Anstey, Herts.; Cambridge, St Peter's. *Corbel*: Southwell, Chapter House. *Misericords*: Chichester, St Mary's Hospital; Windsor. WITH MERMAID: *Misericords*: Exeter; Hereford, All Saints'; Malvern; Stratford-upon-Avon. MERMAIDS PLAYING MUSIC: *Misericords*: Boston, Lincs.; Exeter. WITH FISH IN HAND: *Cornice*: Adderbury, Oxon. *Door*: Barfreston, Kent. *Misericords*:

Beverley Minster; Exeter. SUCKLING LION: *Miseri-cords:* Edlesborough, Bucks.; Norwich; Wells. WITH COMB AND MIRROR: *Boss:* Sherborne, Dorset. *Corbel:* Wrexham, Denbighs. *Misericords:* London, King Henry VII's Chapel; Tewkesbury, Glos.; Welling-borough, Northants. WITH DOLPHINS: *Misericords:* Ludlow, Salop; Nantwich, Ches.; Norwich; Welling-borough, Northants.

SQUIRREL: *Cornice:* Thaxted, Essex. *Bosses:* Exeter; Norwich, cloisters; Oxford, Cathedral. *Stalls and benches:* Lincoln; Little Saxham, Suff.; Sall, Norf.; Stowlangtoft, Suff.; Tostock, Suff. (?). *Misericords:* Bristol; Norwich; Winchester; Windsor.

*SWAN: *Roof:* Mildenhall, Suff. *Boss:* Bristol, St Mary Redcliffe. *Stalls and benches:* Countisbury, Devon; Lakenheath, Suff.; Lincoln; Lyng, Som. *Miseri-cords:* Beverley Minster; Bishop's Stortford, Essex; Cartmel, Lancs.; Leighton Buzzard, Beds.; London, St Katherine's Hospital; Minster-in-Thanet, Kent; Oxford, All Souls; Windsor.

TERROBULI or TERREBOLEM: *Doors:* Alne, Yorks.; Dalmeny, West Lothian (?).

TIGER: *Boss:* Queen Camel, Som. *Stalls and benches:* Lakenheath, Suff.; Wendens Ambo, Essex; Wiggenhall St German, Norf. (?). *Misericords:* Chester; Dunblane, Perthshire; Gloucester.

*UNICORN: CAPTURE OF UNICORN: *Bosses:* Norwich, cloisters; Queen Camel, Som. *Misericords:* Cartmel, Lancs.; Chester; Lincoln; Nantwich, Ches.; Stratford-upon-Avon. FIGHTING THE DRAGON: *Misericords:* Durham Castle; Lincoln; Windsor. SINGLE UNICORNS: *Fonts:* Norton, Suff.; South-

fleet, Kent. *Stalls and benches:* Lakenheath, Suff.;
Milverton, Som.; Sefton, Lancs.; Stowlangtoft, Suff.;
Westwell, Kent.

WHALE. See ASPIDO CHELONE.

*WODEWOSE or WOODHOUSE: *Fonts:* Framling-
ham, Suff.; Halesworth, Suff.; Happisburgh, Norf.;
Ludham, Norf.; Orford, Suff. *Bench:* Colebrooke,
Devon. *Misericords:* Beverley, St Mary's; Boston,
Lincs.; Chester; North Walsham, Norf.; Whalley,
Lancs.

WOLF (ST EDMUND'S WOLF): *Boss:* Norwich,
cloisters. *Stone seat:* Ely. *Stone slab:* Bury St Edmunds,
Moyses Hall. *Benches:* Hadleigh, Suff.; Stonham Aspal,
Suff.; Walpole St Peter, Norf. (BESTIARY WOLF):
Capital: Canterbury, crypt. *Stalls:* Bristol. *Misericord:*
Faversham, Kent.

BIBLIOGRAPHY

M. D. Anderson. *The Medieval Carver.* 1935.

Bartholomaeus Anglicus. *Batman upon Bartholome his Booke "De Proprietatibus Rerum"...Thomas East.* 1598.

Francis Bond. *Misericords.* 1910.

—— *Fonts and Fontcovers.* 1908.

A. H. Collins. *Symbolism of Animals and Birds in English Church Architecture.* 1913.

G. C. Druce. "Animals in English Wood-carvings." *Walpole Soc.* III.

—— "Notes on Birds in medieval church architecture." *The Antiquary,* July, August, October 1914.

—— "Symbolism of the Crocodile in the Middle Ages." *Archaeological Journal,* LXVI.

—— "The Amphisbaena and its connections in ecclesiastical art and architecture." *Archaeological Journal,* LXVII.

—— "Notes on the History of the heraldic Jall or Yale." *Archaeological Journal,* LXVIII.

—— "The Caladrius and its legend." *Archaeological Journal,* LXIX.

—— "Legend of the Serra or Saw-fish." *Proceedings of the Society of Antiquaries,* 2nd Series, XXXI, 1920.

—— "The Ant-lion." *Antiquaries Journal,* 1923.

—— "The Sow and Pigs; a study in metaphor." *Archaeologia Cantiana,* XLVI.

G. C. Druce. "Medieval Bestiaries and their influence on ecclesiastical decorative art." *British Archaeological Association Journal*, xxv and xxvi.

—— "The Pelican in the Black Prince's Chantry." *Canterbury Cathedral Chronicle*, 1934.

—— *The Bestiary of Guillaume Le Clerc*. 1936.

—— "The Lion and Cubs in the Cloister." *Canterbury Cathedral Chronicle*, 1936.

—— "Some Abnormal and composite Human Forms in English Architecture." *Archaeological Journal*, LXXII.

—— "Queen Camel Church; Bosses on the chancel roof." *Somersetshire Archaeological and Natural History Society Proceedings*, LXXXIII, 1937.

Edward, Duke of York. *The Master of Game*. Ed. W. A. Baillie Grohman. 1909.

E. P. Evans. *Animal Symbolism in Ecclesiastical Art*. 1896.

A. C. Fox-Davies. *A Complete Guide to Heraldry*. 1929.

M. R. James. *A Bestiary of the twelfth century*. Roxburghe Club. 1928.

—— "The Bestiary." *History*, New Series, xvi.

—— *The Marvels of the East*. Roxburghe Club. 1929.

—— *St George's Chapel, Windsor; the woodwork of the choir*. 1933.

C. E. Keyser. *Norman Tympana and Lintels*. 1927.

Emile Mâle. *L'Art religieux du XIIIme siècle en France*. 1910.

Sir John Mandeville. *The Buke of Sir J.M.* Ed. G. F. Warner. Roxburghe Club. 1889.

J. Tavernor Perry. "The Salamander." *Reliquary and Illustrated Archaeologist*, New Series, XIV.

Philippe de Thaun. *Livre des Créatures*. Ed. Thomas Wright, F.S.A. 1841.

Emma Phipson. *Choir stalls and their carvings*. 1896.

Pliny. *Natural History*. Translated John Bostock and H. T. Riley. 1855–7. Bohn's Classical Library.

W. J. Thomas. *Reynard the Fox*. Caxton's translation. Percy Society. 1844.

John Vinycomb. *Fictitious Creatures in Art*. 1906.

INDEX OF PLACE-NAMES

The numbers in Italics refer to Illustrations